THE
Archive Photographs
SERIES

AROUND

LEEDS

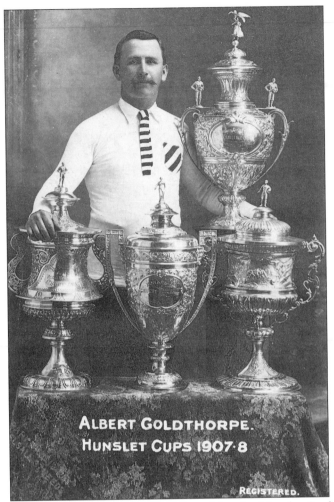

ALBERT GOLDTHORPE.
HUNSLET CUPS 1907·8

REGISTERED.

Albert Goldthorpe stands with the trophies collected by the Hunslet Rugby Football team during the 1907-08 season; the 'Parksiders' won the Northern Rugby Challenge Cup, the Yorkshire County League Cup, the Yorkshire County Challenge Cup and the Northern Rugby League Cup. Goldthorpe was the star player - five feet ten and fourteen stone of Yorkshire powerhouse and a hero to local fans (when heroes really were heroes). A Yorkshire Evening Post article from 1907 stated: "In every town or village in Yorkshire or Lancashire where Rugby Football is played the name of Albert Goldthorpe is one to conjure with. It is no figure of speech to say that Albert Goldthorpe is the most popular footballer in Yorkshire. Every ragamuffin in the street regards him as a personal acquaintance". In a sport struggling to distance itself from the amateur game Goldthorpe had the star quality and profile required - an inheritance passed on to the Schofields and Hanleys of today. Goldthorpe made his debut for the Hunslet club in 1888 and by this cup winning season had kicked over 800 goals. His younger brother Walter also played over fifteen seasons for the Club.

Albert Goldthorpe's inclusion within this edition may seem somewhat anomalous; however when Colonel Harding was searching (in vain) for a suitable local figure to be displayed in City Square it seems to me he failed to cast a wide enough net. Goldthorpe represented the best kind of Yorkshire spirit and a bronze moulding of his Herculean frame would have better embodied the grit and determination of local folk than the present incumbent whose link to the area and the ideal of democracy are extremely tenuous.

THE
Archive Photographs
SERIES

AROUND
LEEDS

Compiled by
Matthew Young and Dorothy Payne

CHALFORD

The Chalford Publishing Company
St Mary's Mill, Chalford,
Stroud, Gloucestershire, GL6 8NX

ISBN 0 7524 0168 8

Typesetting and origination by
The Chalford Publishing Company
Printed in Great Britain by
Redwood Books, Trowbridge

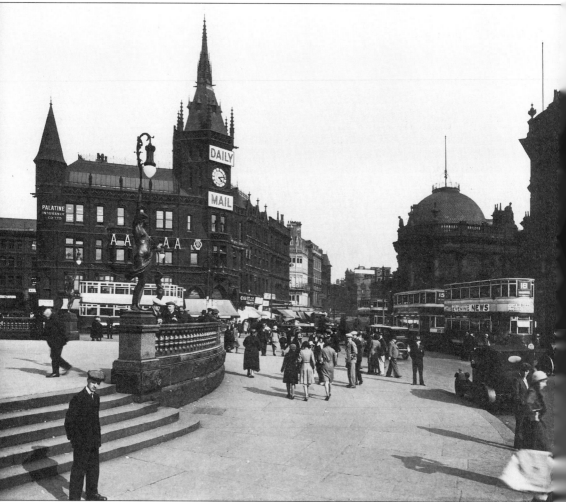

City Square c.1934.

Contents

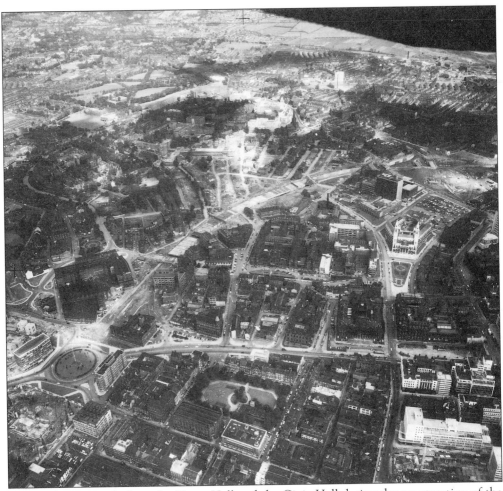

An aerial view overlooking the Town Hall and the Civic Hall during the construction of the Inner Ring Road in 1966 which was optimistically designed to relieve the traffic pressure within the city centre.

Acknowledgements

Many thanks must go to the following: all the staff and volunteers of the Yorkshire Archaeological Society for their sterling, invaluable work in preserving the past; Sylvia Thomas for remaining patient (and interested) during infinite queries; Brian Payne for his advice and patience; Alan Cockroft for allowing me extensive use of his pictorial work; Dorothy for her hard work and understanding. Thanks must also go to the Thoresby Society and Civic Trust: some of their collection originally appeared in Dorothy and Brian Payne's previous editions on the city.

Dedicated to Ashley Owers - a woman who has never lost her keys at a crucial moment.

Introduction

This is not a history of Leeds; several historians and scholars of notes have produced editions chronicling the growth of the city from a cluster of cottages straddling the Aire to contemporary metropolitan sprawl - yet another would seemingly be grist t'mill. This book is a display of some of the best photographs held by the Yorkshire Archaeological Society, the West Yorkshire Archive Service and private individuals around the city. Many of the images presented here are published for the first time; others have appeared before but I remain unrepentant about their inclusion - the best photograph, like the best art, never tire the receptive eye. Roland Barthes is his book 'Camera Lucida' stated that an old photograph doesn't allow us to wallow in nostalgia but simply reminds us that the past was real - just like now. For me these images of Leeds never fail to astonish: the congested streets of Boar lane at the turn of the century demonstrate that traffic problems are not a contemporary issue; the sheer scale of the Quarry Hill estate; the contrast between the squalor and condition of the 'Yards' and the thriving community that lived within them. Mies van der Rohe said that 'God is in the details'; these photographs may not quite show that the Almighty has had a direct hand in the building of Leeds but they are richly soaked in detail and reward repeated viewing.

The design of Leeds has often been a tussle between several forces - economic, council, geography, fashion - but it remains a city with a vibrant heart and, above all, a civic pride. While many city centres wither in the onslaught of peripheral multiplexes, shopping malls, retails stores and twenty-six lane bowling centres Leeds has retained its core. It has bustle and activity; it has life. The course to the present though has been far from smooth. I stand in awe of the inspiration that combined to build the Town Hall; the egalitarian pulse which created the Civic Hall and the Quarry Hill Estate; the desire for a central square to celebrate the ideals of a newly created city. However, such emotion are always tempered with the knowledge that petty bureaucracy, architectural horrors and political ideology have been a historical accompaniment: the reduction of the cenotaph to an irritating traffic bollard forcing its removal; the dismissal of Queen Victoria from the front of the Town Hall to the relative ignominy of Woodhouse Moor where she joined her fellow exiles Peel and Wellington; the failure to find a single 'local' worthy to stand in the prime site of City Square; the removal of the Standard Life Assurance building to be replaced by the utter mediocrity of the Norwich Union building. On the outskirts of the centre the demolition of such areas as Bramley Town Street, parts of Burley, and acres of 'yards' in Hunslet may have politically and

economically expedient but the ideas of 'renovation' or 'community' were never considered. Today, thankfully, preservation is no longer a dirty word and re-building rather than replacement is common currency but redtape and his close relatives, officialdom and financial restraint, remain lurking in the shadows.

The areas shown within this book have been divided into two sections: the city centre and the environs. I wanted to include views from around the outskirts (however cursory) as a city is essentially homogeneous - although, like a person, it has a diversity of parts it functions as a whole. Some photographs were also too good to ignore: areas of Armley, Bramley, and Hunslet that have vanished into memory; smiling faces in open doorways; children actually playing in the streets; row upon row of drying clothes on lines strung from house to house; roads without cars. The pace of life has quickened but sometimes, just occasionally, there is a need to stop and contemplate what was and what might have been.

<div align="right">

Matthew Young
March 1995

</div>

The Yorkshire Archaeological Society was founded in 1863 to study and preserve antiquities in the Huddersfield area. After moving to Leeds in 1896 it soon expanded both its membership and its interests to include the whole of the historic county of Yorkshire. Today the Society, with some 1400 members - many abroad, caters for people interested in every aspect of Yorkshire's history and archaeology.

<div align="right">

Dorothy Payne
Publicity Officer
Yorkshire Archaeological Society
23 Clarendon Road, Leeds

</div>

The West Yorkshire Archive Service exists to preserve the county's heritage of historical documents and help members of the public to make use of them. The Service, which is jointly funded by the Metropolitan Councils of Bradford, Calderdale, Kirklees, Leeds and Wakefield, has offices in each of the five districts and at the Yorkshire Archaeological Society's premises in Leeds.

<div align="right">

Sylvia Thomas
West Yorkshire Archive Service
Leeds District Archive
Chapletown Road, Sheepscar

</div>

One
Central Leeds

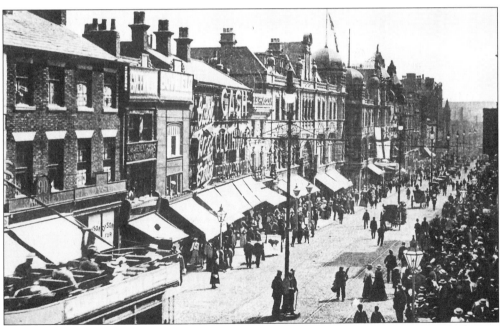

A view down Briggate c.1912. Briggate has been the heart of Leeds for over eight hundred years. Originally a 'wide' street leading to the bridge it assumed prominence in the Seventeenth Century when the cloth market which was held on the Leeds Bridge outgrew its surroundings and was relocated. In recent times the street has competed with Boar Lane and the Headrow for prestige but it remains the nucleus of the city.

Fresh milk deliveries for businesses on Briggate in 1892. The trams on Briggate at this time were still pulled by horse; electrification of the system occurred around the city centre during the next few years.

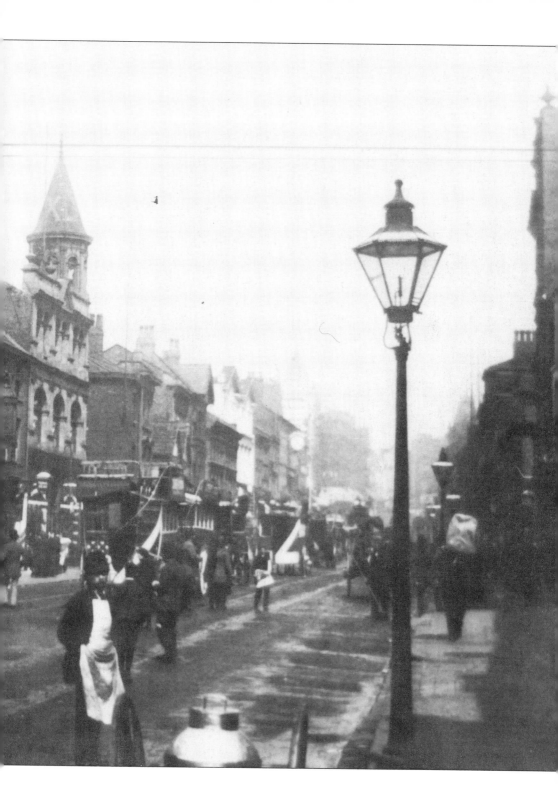

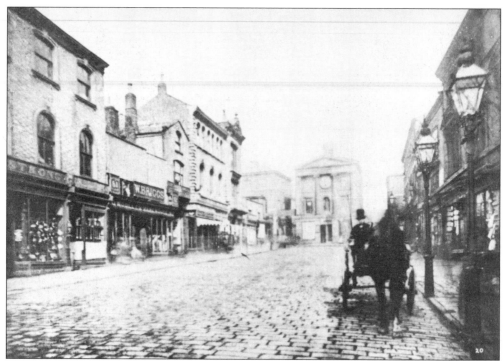

The top of Briggate in 1880. Jackson and Briggs, numbers 81 and 82, were wholesale and retail stationers but the premises changed ownership soon after this picture was taken - the buyer was J. Sears and Company (Boot and Shoe dealers).

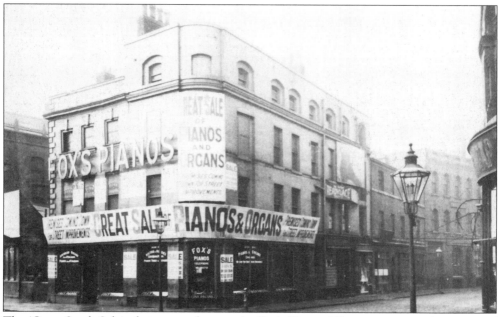

The 'Great Stock Sale' of pianos and organs by Fox's Pianos. The premises, on the corner of Briggate and Swinegate, were demolished for road improvements.

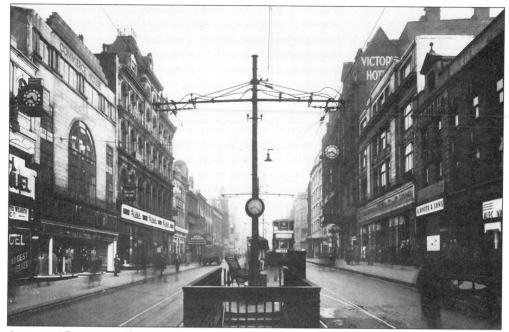

A view up Briggate in the 1930's. Commerce House on the left contained several businesses at this time including Ornstein and Massoff Ltd (Gown Manufacturers); G.A. Mitchell and Company (Estate Agents) and the touchingly named Proper Size Dress Company Ltd. At the bottom of the Imperial Hotel were Burton (Montague) Ltd opposite A. Booth and Sons (Tailors). Further down the street a Basil Rathbone feature was playing at the Rialto Cinema.

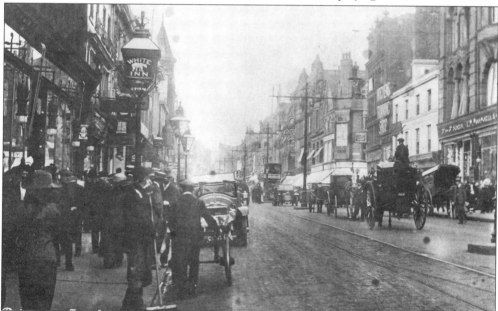

Briggate c.1920. The distinctive Boots logo can be seen on the corner with King Edward Street; Stead and Simpson were located next to Hitchen Trading Company, a drapers founded in 1879. Parked in the centre of the street are the Hansom Cabs still plying a trade in an increasingly competitive market.

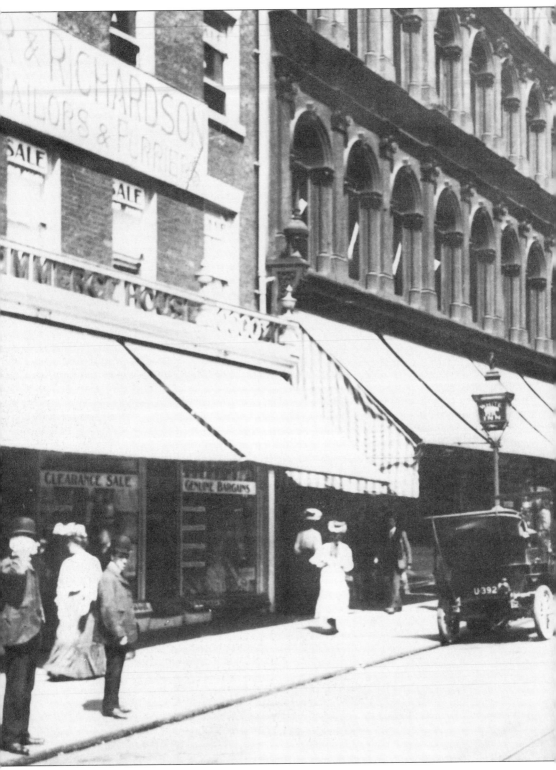

Briggate c.1910.

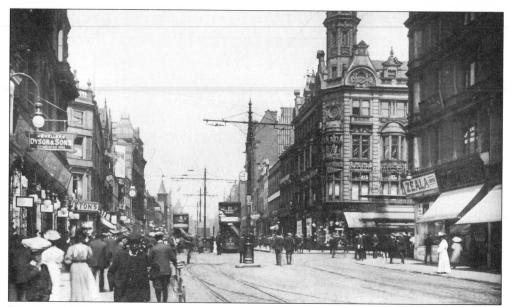

Briggate c.1912.

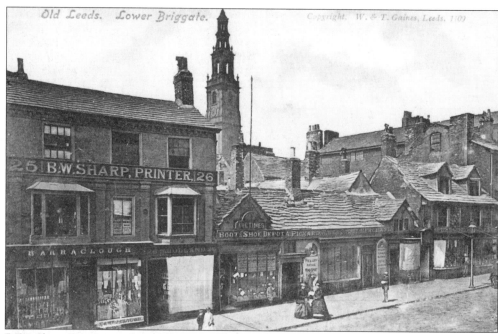

B.W. Sharp Printers on Lower Briggate. This site later became a Jewellers belonging to Dyson and Sons. Next door was Pickard and Whitting Company: the 'extraordinary' Pickard family ran three separate enterprises under the umbrella of the company name: wines and spirits, tobacco, drapery.

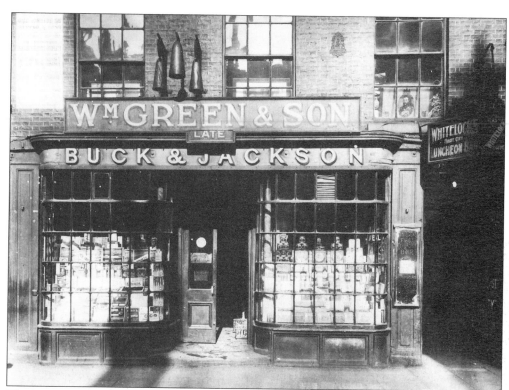

The last bow windowed shop on Briggate which belonged to William Green & Son (formerly Buck & Jacksons) was demolished in 1922. The passage to the right led to Whitelocks Luncheon Bar.

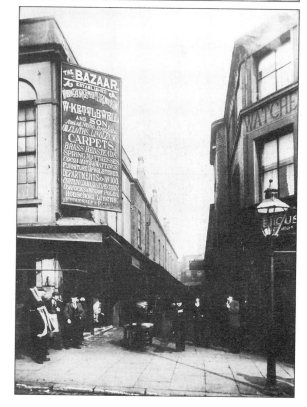

The Bazaar at Briggate which was demolished in 1899. This view is looking down Cheapside toward Vicar Lane in 1893. Amongst the essential items for sale were linoleum, brass bedsteads and cocoa mats.

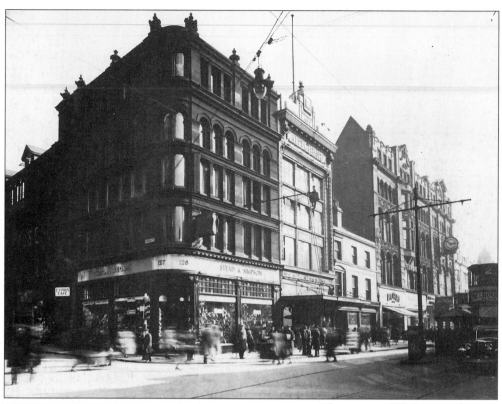

The corner of Kirkgate and Briggate in 1951.

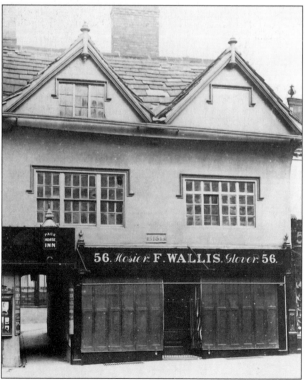

Wallis's Hosier and Glover was demolished and eventually replaced by Timpsons Shoe Shop in 1955. It was the last medieval building left on Briggate.

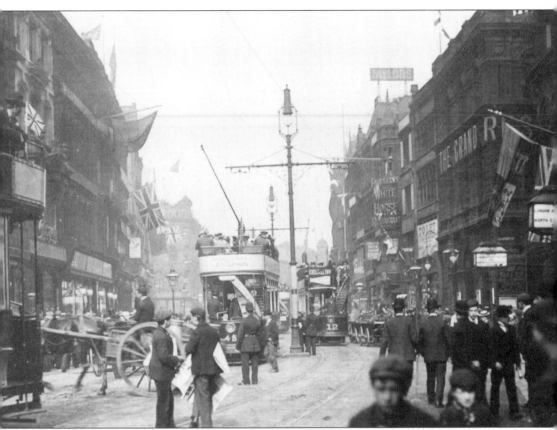

Peace Day on Boar Lane in 1901. Although this was a Sunday a special edition newspaper was produced to celebrate the end of the Second Boer War. The shouts of the paper boys brought people into the centre from as far away as Kirkstall.

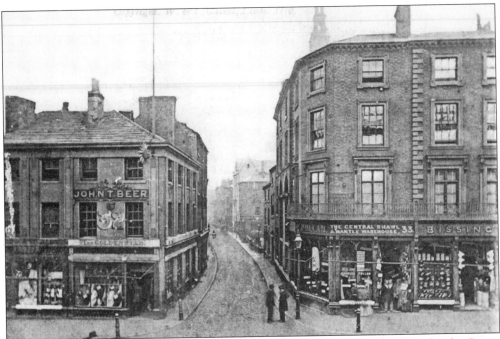

Old Boar Lane at the junction with Briggate just before the entrance was widened. John Beer was a clothier and hatter; Pullans was a shawl and mantle warehouse; Bissington's sold hosiery and hats.

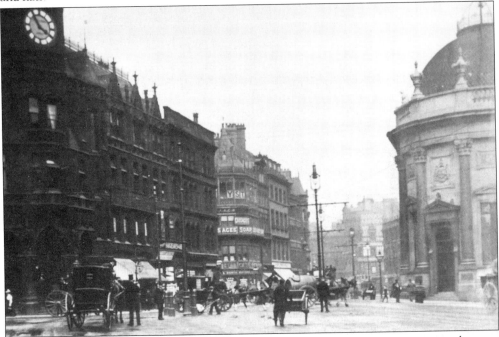

Boar Lane at the junction with City Square and Bishopgate c.1890. Boar Lane was to become 'the' shopping street during this period - a title it lost to the Headrow after construction in the 1930's. Today, Boar Lane, like an elderly film star, retains a certain faded grandeur and is undergoing a radical surgery to halt decline and recreate old prestige.

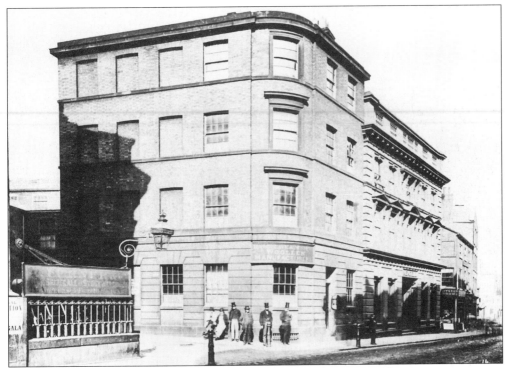

The old buildings on the corner of Boar Lane and Basinghall Street c.1881.

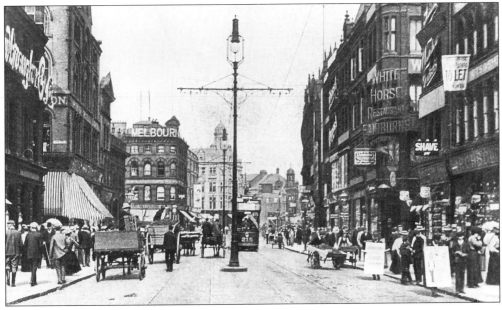

Boar Lane in 1920.

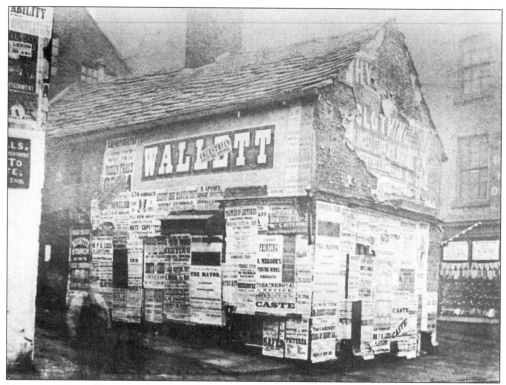

Norton's Oyster Shop, south side of Boar Lane c. 1869. John Norton is listed in Whites Street Directory (1853) as a grocer, fruiterer and oyster dealer. This photograph must have been taken just before demolition to widen access to Boar Lane.

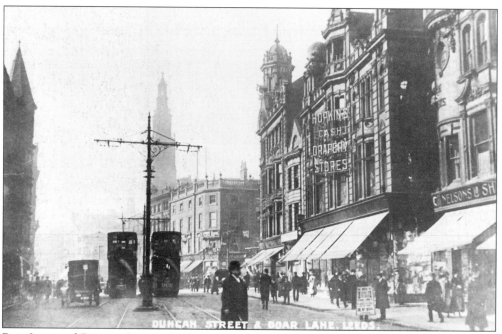

Boar Lane and Duncan Street c.1922.

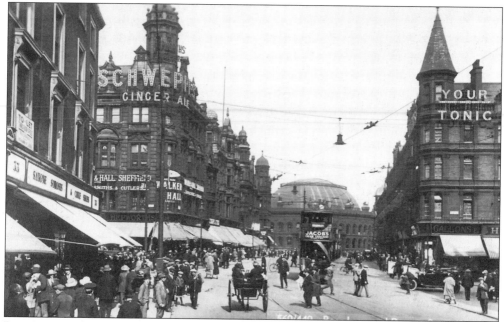

Boar Lane and Duncan Street in the 1930's. Hepworths on the corner with Briggate share premises with Goldsmith's Walker and Hall. Gallons Ltd on the corner of Duncan Street were grocers with several sites around Leeds. The 'pustular' Corn Exchange, designed by Cuthbert Brodrick and constructed in 1861, has been variously described as 'magnificent', 'inspiring' and 'forbidding'; for others it stirs little emotion beyond admiration for the building contractors faced with plans that did not contain a straight line. The reconstruction of the interior was remarkable - an exercise in taste and subtlety.

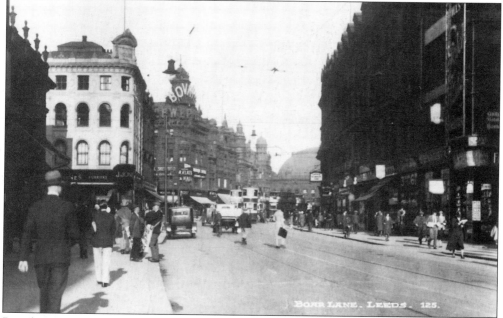

Boar lane 1951 with Trinity House on the corner. The back of this postcard reads (somewhat tongue in cheek), 'Boar Lane hasn't altered much since you left!'.

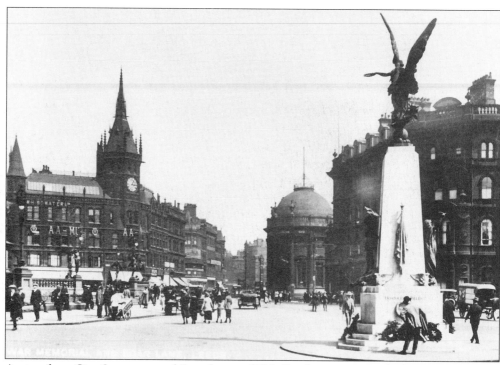

A view from City Square toward Boar Lane c.1920. On the corner stands the tower adorning the Royal Exchange House. This was later replaced with the perfunctory and uninspiring building that stands beside Mill Hill Chapel and adjacent to the Queens Hotel. The cost of the new building, designed by John Brunton, was £5.5 million but lacks the charm of the previous tenant.

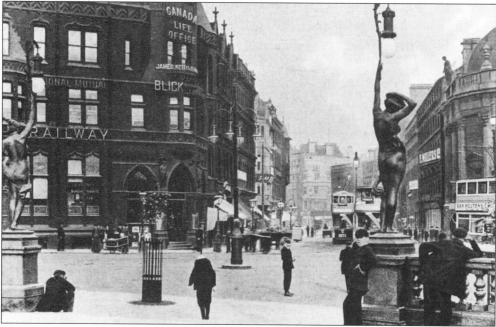

A view from City Square towards Boar lane in the 1930's.

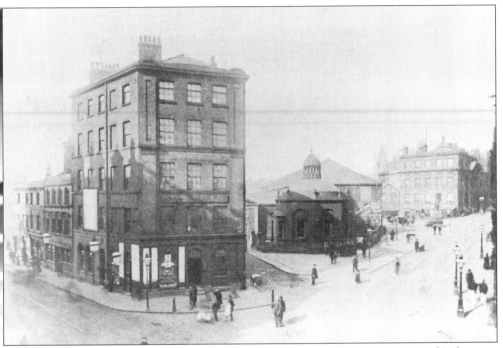

A view of City Square in the 1870's before construction taken from the junction of Bishopgate and Boar Lane.

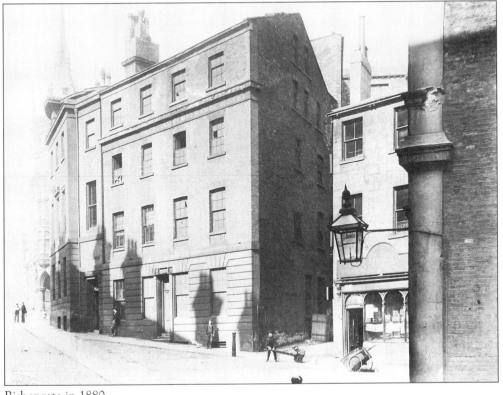

Bishopgate in 1880.

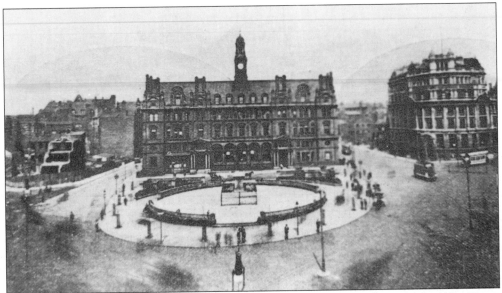

The Post Office building before the inauguration of City Square in 1903. Designed by Henry Tanner in 1896 it still dominates much of City Square although years of battering pollutants have given the brick facade a somewhat sooty appearance.

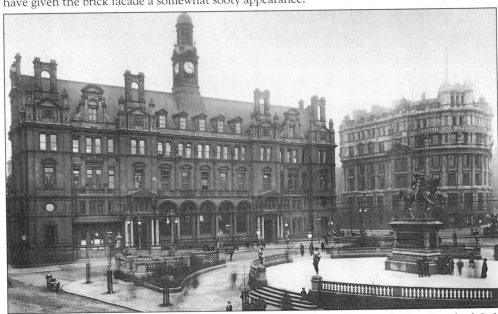

City Square and the Post Office building c.1910. To the right stands the Standard Life Assurance building in majestic splendour; completed in 1901 it was demolished to make way for the more 'functional' Norwich Union building. This truly hideous box is thankfully in the process of demolition; Norwich Union having sensibly fled several years ago. Patrick Nuttgens, writer and broadcaster, ably described how rail travellers arriving in Leeds would emerge into the light to be confronted by the full architectural power of the Union Building. He did not mention how many simply turned around and bought a ticket home. Even during the construction the building caused problems: one of the contractors managed to block all drains around City Square with cement.

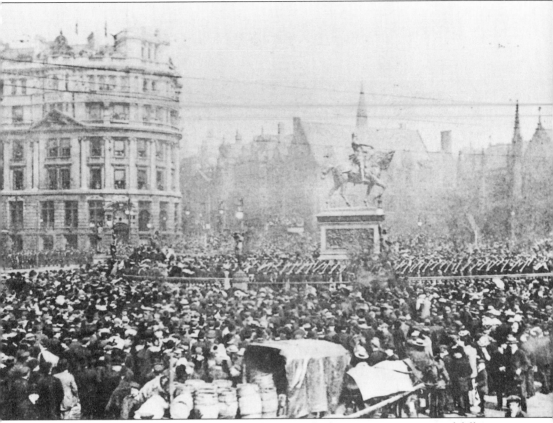

The inauguration of City Square September 16th 1903. The bunting was put out and full civic pomp displayed as Colonel Harding's own regiment The Bradford and Leeds Voluntary Artillery led a procession which marched down from the Town Hall at midday bringing all traffic to a halt. The notion of a 'central square' had been mooted for several years following the grant of city status. The Leeds Corporation in 1896 put forward a proposal to build a subterranean lavatory and a tramway waiting room. Colonel T. Walter Harding, a man of somewhat greater vision than many of his contemporaries, suggested a square with suitable adorned figures. The idea was adopted but the name was a source of disagreement between the Lord Mayor and the Chairman of the Leeds Property Committee until the momentous decision was reached to title the new central area 'City Square'. Colonel Harding donated the principal sculpture, the Black Prince, which was designed by Thomas Brock. Brock's original sketches were altered after complaints that the Prince looked too 'effeminate' and rather 'pretty' - consequently drawings of a more sturdy and masculine figure appeared. Eventually the bronze was cast in Belgium and brought to England by barge; the final journey to City Square was undertaken by six horses. The choice of the Black Prince was, and has been, the subject of debate. The connection of the Prince to the area is tenuous and the notion that no suitable 'local' existed is ludicrous. However Colonel Harding paid the final bill and during the Inauguration speech he was unrepentant if somewhat gushing: "I confess I do not regret the selection of the Black Prince, the hero of Crecy and Poitiers, flower of English chivalry, upholder of the liberties of the English . . .".

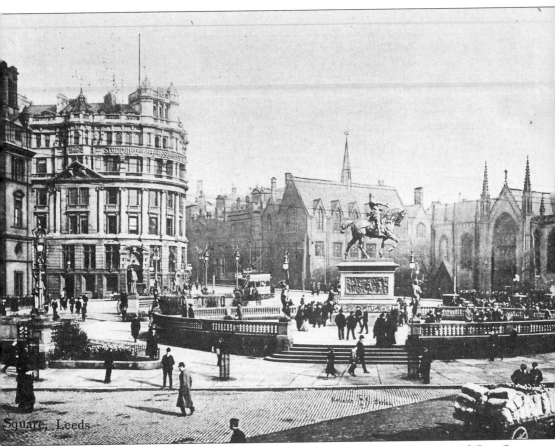

Square, Leeds

City Square in 1921. Under twenty years had passed since the Inauguration of City Square when Colonel Harding berated the Local Council for the 'deplorable state in which the Square has been allowed to get'. The trees around the square had been removed although the Council later suggested placing new trees and shrubs in pots around the perimeter. Sympathy must lie with Colonel Harding as he watched the erosion of his project: for several years after the inauguration he employed an attendant whose duties included the 'removal' of litter and stopping individuals who sought to strike their matches on the voluptuous bottoms of Even and Morn.

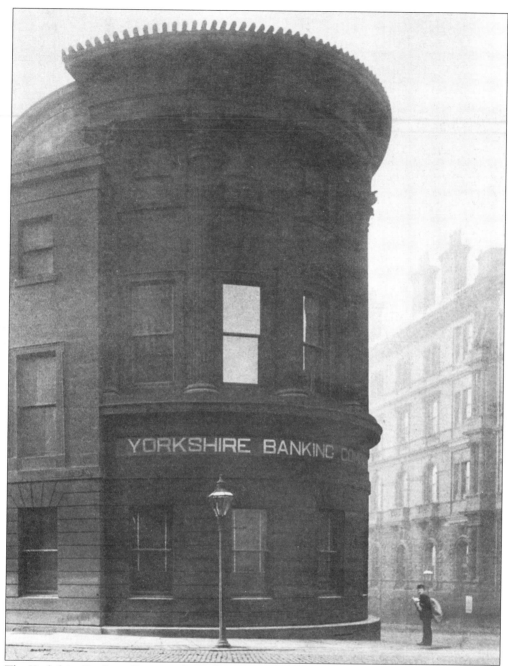

The Yorkshire Banking Company Branch on City Square c.1880. This original building built in 1836 was replaced and has undergone several changes of ownership and use. Today it houses the Observatory Cafe Bar but the faded letters of 'Yorkshire Banking Company' can be seen around the brickwork and the fence railings still bear the company initials.

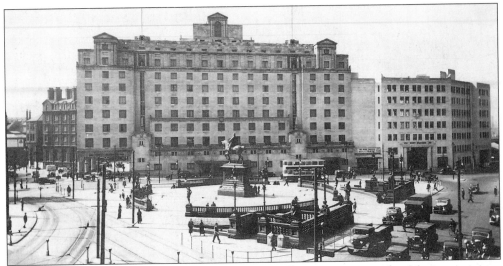

Queens Hotel City Square in 1937 doing an excellent impression of a Moscow ministry building. The original Queens Hotel was constructed along more classical lines in 1963 under the direction of architect William Perkins but failed to survive the passage of time; the Earl of Harewood opened the present building in March 1937. In the foreground are the City Square underground lavatories (Gentlemen's on the right) where a hot bath was also available. Today these 'Water Closets' are 'vacant' as they were simply covered over during developments.

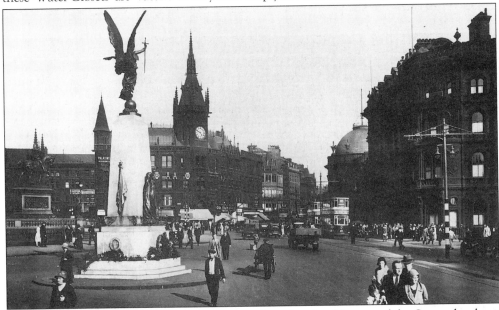

City Square in the 1930s. Since this view was taken the visual impact of the Square has been gradually diminished. The air pollutants have seeped into brick and bronze alike and various road 'improvements' have reduced the actual paved area. Colonel Harding's grand vision has become something of a staid sideshow. There have often been several campaigns launched to restore some of the Edwardian glamour to the site: in 1993 a philanthropic soul even offered to return to the Council the balustrading that surrounded the old lavatories. These anecdotes make good news stories but City Square, if it is to retain any visual impact, must undergo extensive restoration and a reduction in the traffic that flows around it.

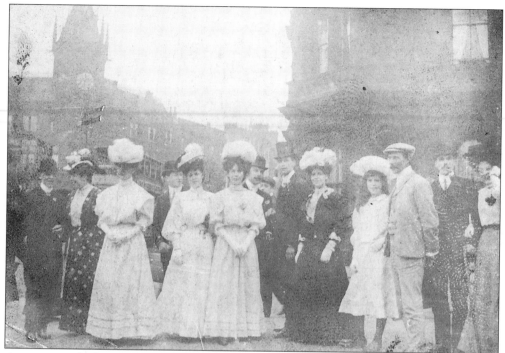

A group outside the Royal Exchange Building in 1908. This photograph was probably taken for the Royal visit of July 7th.

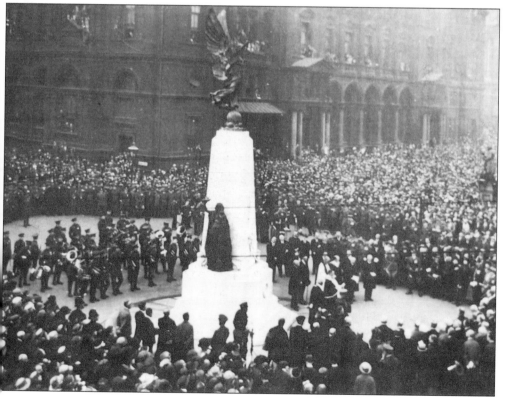

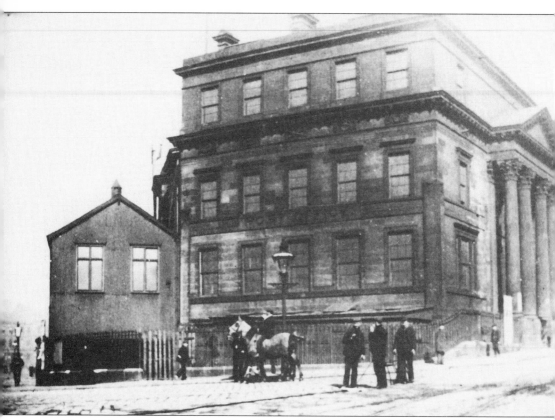

The old Post Office building on Park Row c.1880 was originally built as a Courthouse in 1813 but was purchased by the Post Office in 1861. A third storey was added in 1872 to administer postal telegraphs but the building became redundant when the General Post Office was built in 1896 on the site of the old Cloth Hall on City Square.

Page 31 bottom: The opening ceremony of the War Memorial in City Square presided over by the Lord Mayor Albert Braithwaite. Colonel Harding had suggested City Square as a site after a scheme to place the monument near Cookridge Street became prohibitively expensive. After several internal squabbles the Leeds Memorial Executive compromised, albeit with little grace, and H.C. Fehr of London was commissioned to create a suitable piece for public display costing £5000. The cenotaph with Victory rising above her relations of War and Peace is a noble tribute to the fallen but a sense of scale is lacking and detracted from the centre piece of the square. As traffic increased the roads and access around City Square widened, the monument was reduced to little more than a hazardous traffic bollard and was removed to its present site near the Town Hall. The statue of Victory was removed in 1937 and taken to Cottingley - a replacement now perches upon the monument.

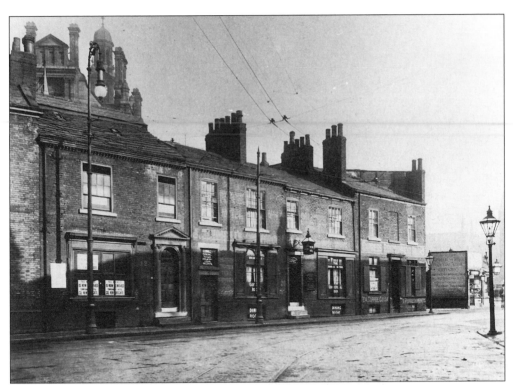

Wellington Street c.1920. The tower of the Post Office is visible in the background.

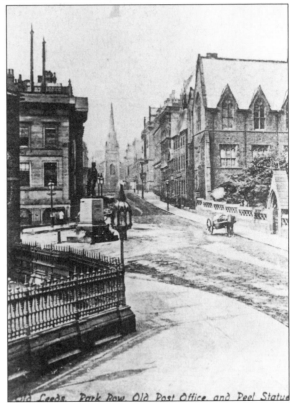

Park Row and the old Post Office c.1865.

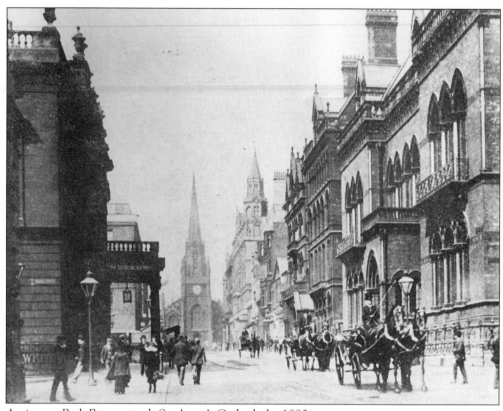

A view up Park Row towards St. Anne's Cathedral c.1880.

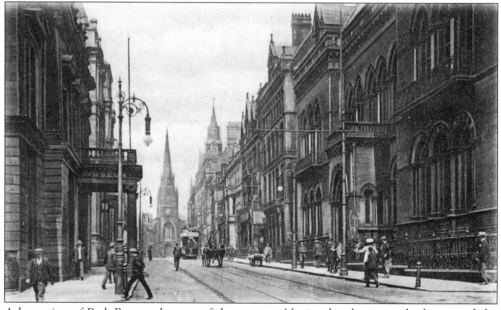

A later view of Park Row at the turn of the century. Notice the change to the lamps and the ornate styling of the latter.

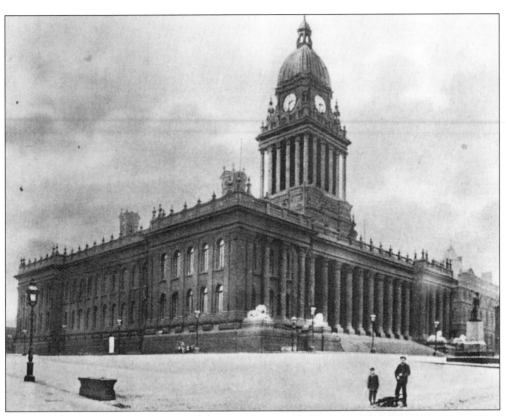

Outside the Town Hall at the turn of the century. Standing for any length of time on the corner of Oxford Place and Westgate today will probably result in a rapid visit to the A & E Department; but one hundred years ago it was possible to reach the Town Hall without risking limbs or an assault upon the respiratory system. The design of the Town Hall came from a competition won by twenty-eight year old architect Cuthbert Brodrick. At the time of submission Brodrick had been living with his parents in Hull and completed most of the design in the attic. In true overbearing maternal style Brodrick's mother advised her son to scrap his plans and in true youthful subversion Cuthbert ignored her. The judge, Sir Charles Barry, a devotee of classical architecture recognised a fellow spirit and awarded the design to Brodrick. To what extent Brodrick 'tailored' his plans to suit the passions of the judge remains uncertain but the building itself is a masterpiece and still rightfully dominates the skyline.

A view of the Town Hall taken from the Portico of Scott's elegantly designed General Infirmary.

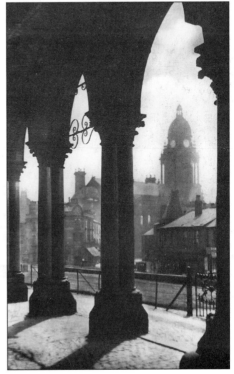

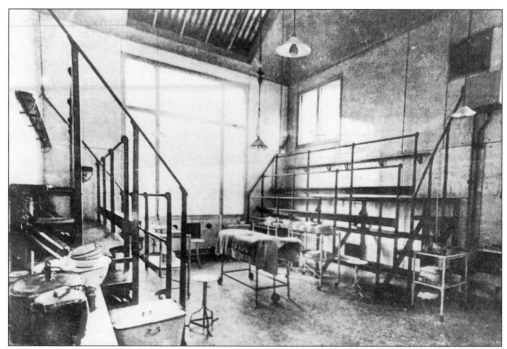

A picture of one of the first operating theatres at Leed General Infirmary. Doctor S.T. Anning, writing in 'The General Infirmary at Leeds' believed this photograph was taken by Doctor E.G. Fowler.

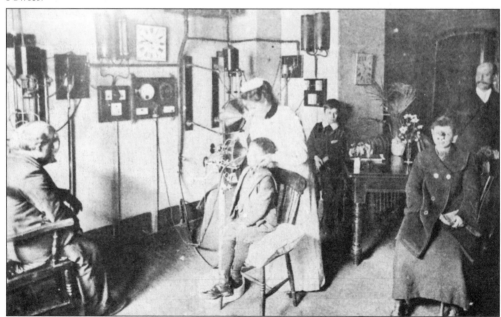

Finsen Light Room c.1905. Niels Ryberg Finsen (1860-1904), a Danish Physician, discovered the therapeutic effect of using ultra-violet rays for diseases of the skin. The first lamp was used in the Infirmary in 1901 but such was the effect upon dermatological conditions that a second and third lamp had been purchased by 1903; by this date up to sixty persons a day were being treated.

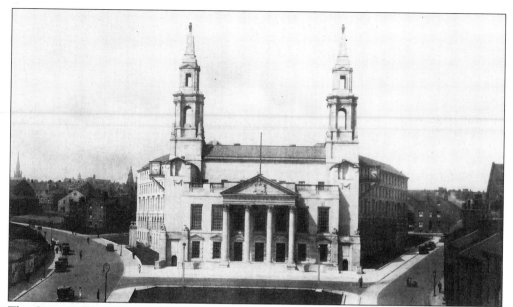

The Civic Hall was designed by E. Vincent Harris utilising a steel girder skeleton and faced with Portland stone. Built in 1933 at a time of great economic depression ninety percent of the workforce were taken from the unemployment register - a sensible (and inspiring) mixture of public works and civic responsibility. Upon the twin towers, which reach 170 feet, perch two gilded owls; the interior contains a council chamber and reception hall. The Hall was opened in August 1933 by King George and Queen Mary and is currently undergoing renovation. The caption on the back of this postcard also gleefully announces that the opening 'gave us a whole day off school'.

The old buildings on Great George Street. On the left is the 'Victoria Pub' and on the far right the old Masonic Hall built in 1866. The house in the centre was built by George Corson in 1865 for the famous Leeds photographer Wormald.

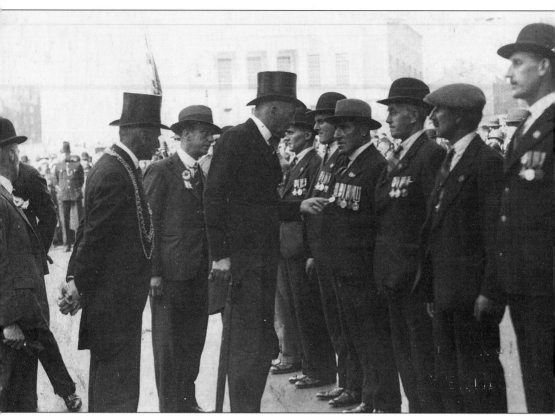

The Annual Rally of the North East Branch of the 'Old Contemptible Association', August 20th 1933. Over 500 members of the Association walked under banners from Sheffield, Leeds, Huddersfield, Halifax, Hull, Harrogate and Bradford and were presented to General Sir Grathorne Hardy (Earl of Cranwood) and the Lord Mayor of Leeds, Alderman R.H. Blackburn in front of the Civic Hall. The name 'Old Contemptibles' came from the Kaiser's remarks concerning the British Expeditionary Force: '. . . exterminate the treacherous English and walk all over General French's contemptible little Army'. The courage displayed by the BEF at Mons, Landrecies and Le Cateau demonstrated that they were anything but 'contemptible'.

Opposite: An illuminated tramcar decked out to celebrate the Royal visit in 1908. Illuminated trams were a regular sight around the city but the 'royal' tram decorated in University Colours ran for a week during the visit. The route started from Victoria Square and visited Boar Lane, Briggate and Vicar Lane: the Lord Mayor was upon the inaugural trip.

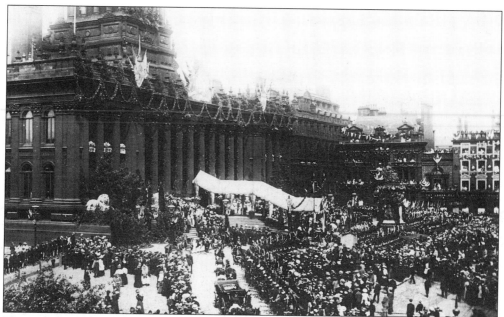

The visit to Leeds of King Edward VII and Queen Alexandra on July 8th 1908. Three quarters of a million people came onto the streets of Leeds in an attempt to see the King and Queen. Boar Lane and Briggate were 'unrecognisable' in decorations of flags and flowers. The ambulance staff (Shipley branch) reported several faintings while one youth climbed a tram standard (pole) and refused to come down until after the procession had passed. When he eventually reached the ground he was arrested and 'a melee ensued' in which the crowd took the 'youth's part' and 'the police had to use their batons to maintain order'.

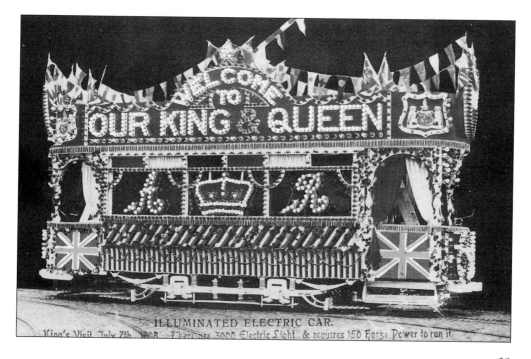

ILLUMINATED ELECTRIC CAR.
King's Visit July 7th 1908. There are 3000 Electric Light & requires 150 Horse Power to run it.

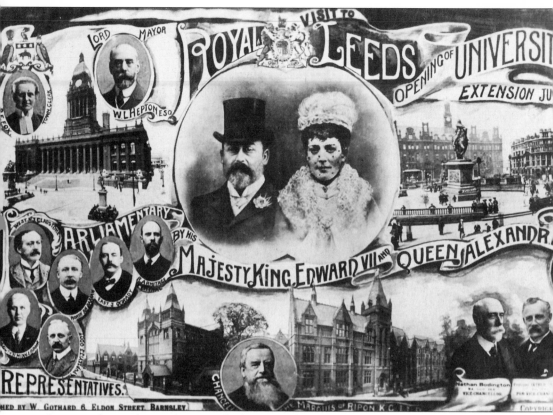

A postcard was also made to mark the visit: the centrepiece featured the King and Queen surrounded by the faces of almost every council official and local dignitary associated with Leeds including Lord Mayor Hepton, Town Clerk Fox and University Chancellor - The Marquis of Ripon. Obviously applying the dictum 'fame by association' their names are forever linked with the House of Saxe-Coburg-Gotha.

The Headrow in 1935. The street was re-designed as Leeds 'Grand Avenue'; while not as grand as the Champs-Elysées or The Mall it is infinitely more practical: The Champs-Elysées was designed to allow the French cavalry easy access to protesting Parisien hordes while The Mall allows the reigning monarch to open their bedroom curtains upon a nice long vista. Designed by Reg Blomfield The Headrow provided a relief for Inner City traffic and also surpassed Boar Lane as a consumers paradise.

Shopping on the Headrow in the 1930s.

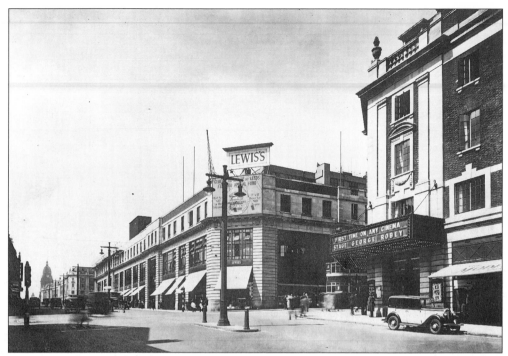

Lewis's was the centrepiece of the new Headrow. A super store to rival those in London and New York. The site alone cost £160,770 and the building over £750,000: further floors were added after opening. The work on Lewis's was never fully completed and the building's impact is still somewhat diminished from that envisaged.

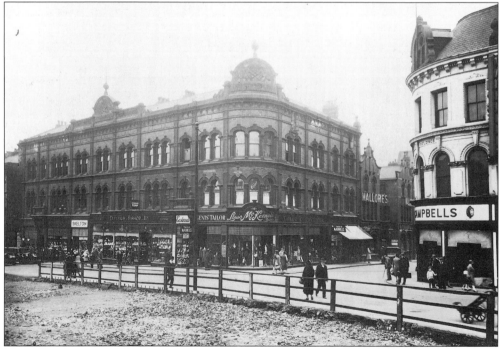

Upper Headrow in 1930.

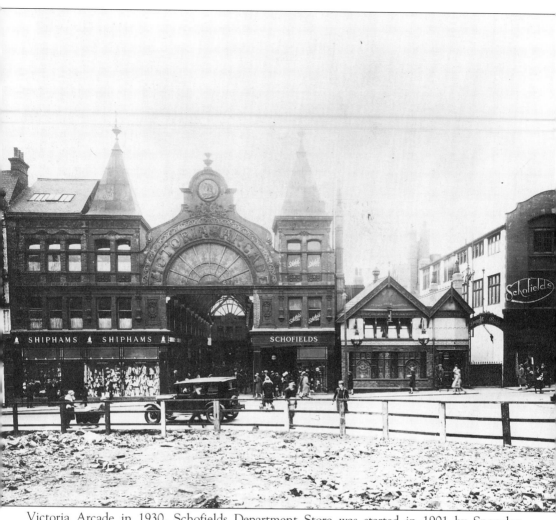

Victoria Arcade in 1930. Schofields Department Store was started in 1901 by Snowden Schofield. The first day's takings on May 4th 1902 were £62 3s (of which £43 10s was in gold). The business expanded but remained on two sites: the stumbling block to expansion was the Cock and Bottle Inn which neatly divided the Schofield empire. Eventually in 1938, the Inn was bought and Schofields could display a single front. The Victoria Arcade, which allowed access at Lands Lane or the Headrow was demolished in 1959 to allow greater floor space for the store.

The corner of The Headrow and Vicar Lane c.1900.

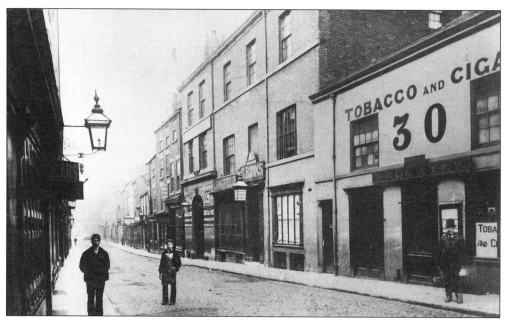

Vicar Lane c.1900.

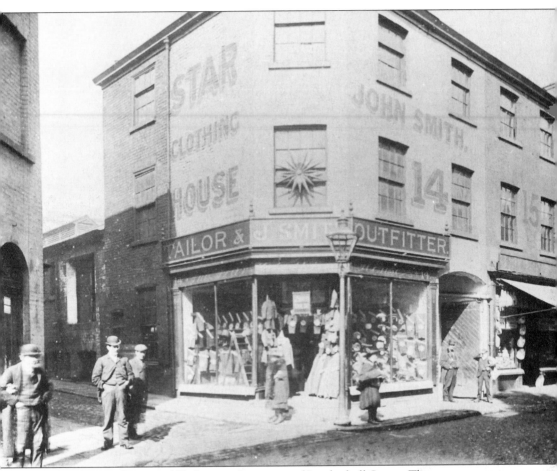

John Smith's Outfitters and Tailors on the corner of Leadenhall Street. The narrow entrances pictured here led to the slaughter houses.

Next: Leadenhall Slaughter House on the corner of Leadenhall Street and Vicar Lane c.1885. This slaughter house, situated behind the old Dolphin Hotel, was convenient for the Smithfield meat market on Cheapside; the Smithfield was demolished in 1886. Inadequate drainage within the slaughter house allowed a regular 'tide of blood' to flow onto Vicar Lane.

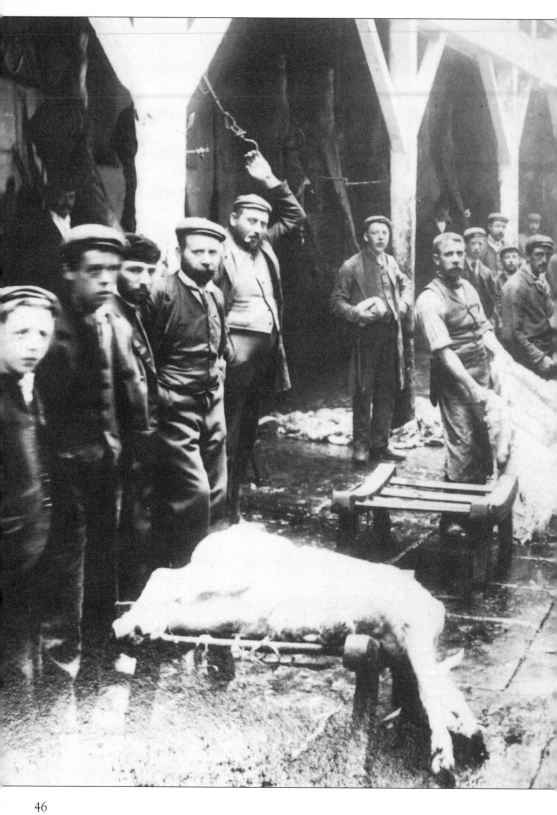

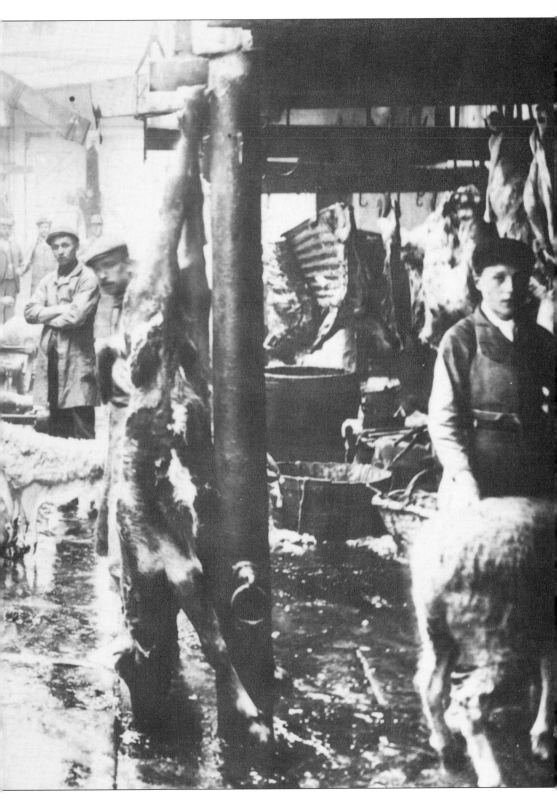

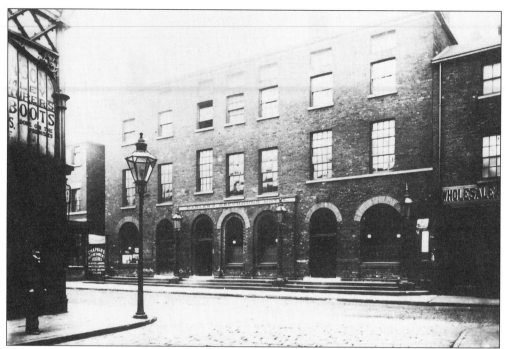

Vicar Lane 1891. On the left the old market buildings would be demolished in 1902 to make way for a new structure; over the road stands The Greyhound Hotel, formerly the House of Recovery.

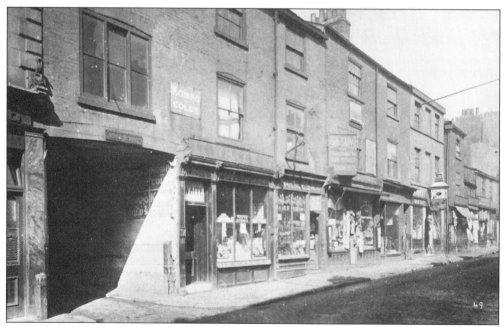

The entrance to Wood Street from Vicar lane c.1910. Wood Street was named after Joseph Wood, the prosperous Leeds milliner.

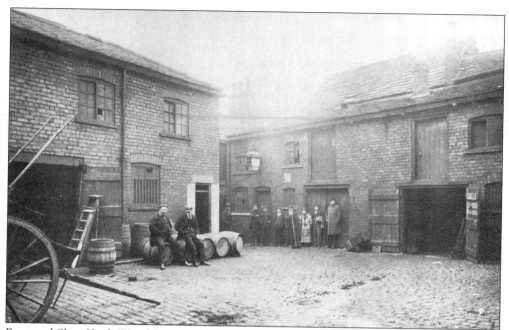

Boot and Shoe Yard, Wood Street c.1890. The contents of the barrel stored in this yard would later be consumed (in earnest) at the Boot and Shoe Inn on Wood Street.

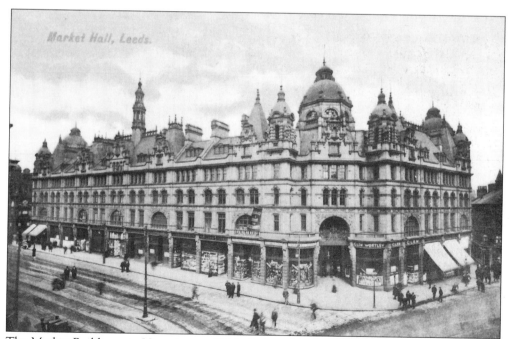

The Market Buildings on Vicar Lane c.1910. Designed by Leeming and Leeming of Halifax in 1904 the elegant, classical stone front housed a series of shops within the arcade. A market had been held on the site since 1823 and a hall was erected in 1854.

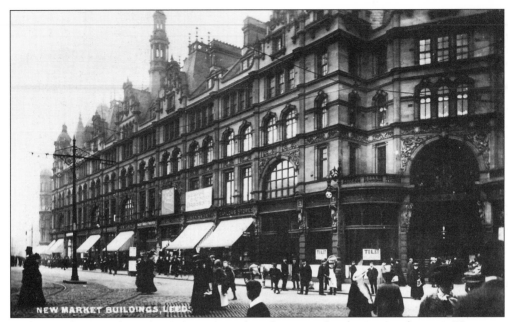

In 1975 a fire gutted much of the interior but the stone facade remained intact. However, during recent renovations to the roof the dome over this entrance was set ablaze.

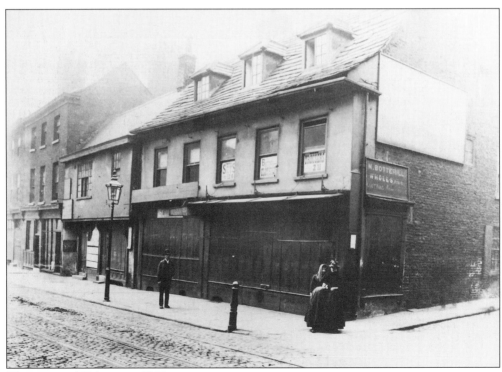

The corner of Kirkgate in 1890.

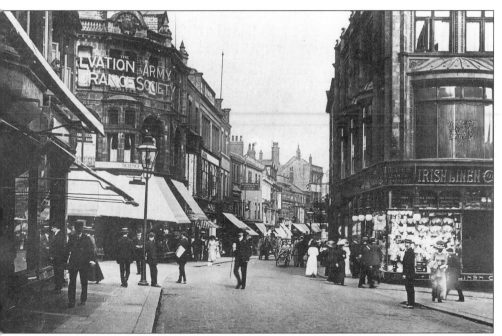

Commercial Street c.1901 at the junction with Lands Lane.

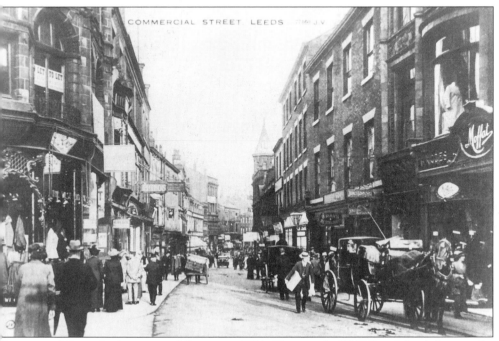

Commercial Street looking toward Briggate c.1901. The sign for W.H.Smith bookshop can be seen on the north side.

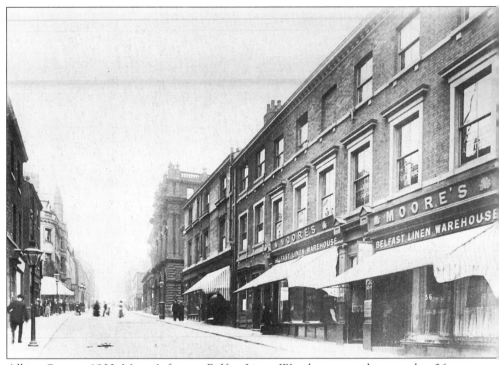

Albion Street c.1900. Moore's famous Belfast Linen Warehouse stands at number 36.

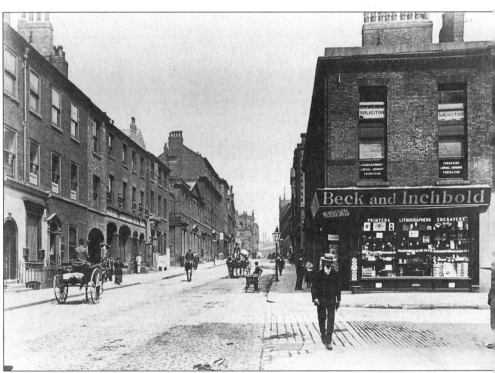

A view down Albion Street c. 1900.

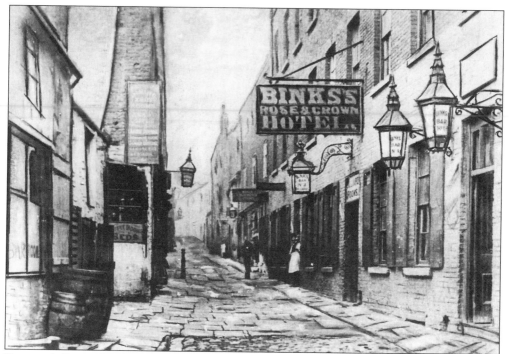

Rose and Crown Yard in 1887 allowed access to Briggate from Lands Lane. The yard was demolished to make way for the Queen's Arcade.

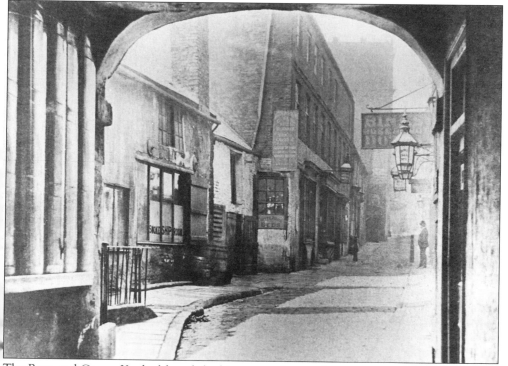

The Rose and Crown Yard, although looking somewhat seedy, was extremely fashionable: tea could be taken at Morleys; stronger beverages were available at Bink's Hotel.

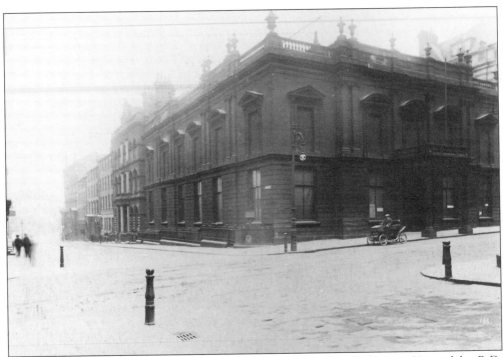

Philosophical Hall on the corner of Bond Street c.1907. The Hall was designed by R.D. Chantrell in 1819 and has exhibited a variety of items including Egyptian mummies and Mexican antiquities. The cost of entrance in 1844 was listed as sixpence.

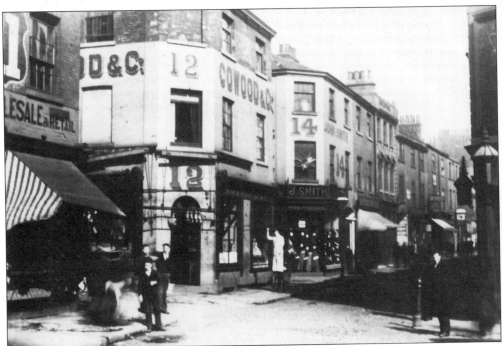

Vicar Lane in 1890 before road alterations widened the entrance for traffic access. Cowood and Company sold general provisions.

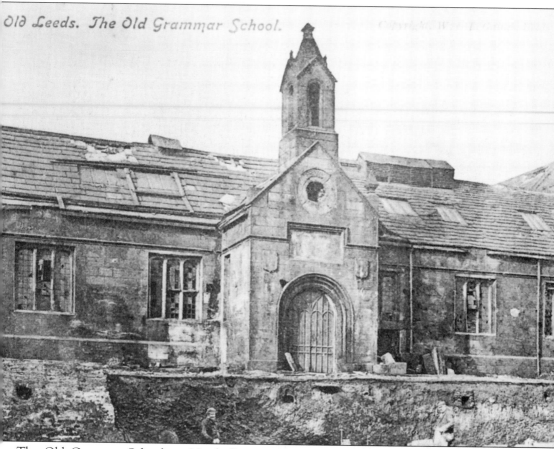

The Old Grammar School on North Street c.1893. Built by John Harrison in 1624 the Grammar School has its roots back in Sixteenth Century. This building was vacated for the Clarendon Road site in 1859. For a time it was used as a foundry but this photograph must have been taken shortly before demolition in 1894.

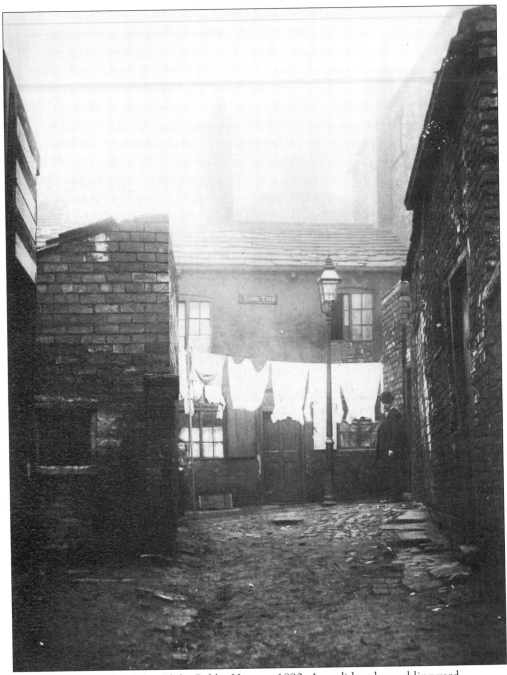

The Globe Yard behind the Globe Public House c.1890. A sordid and crumbling yard.

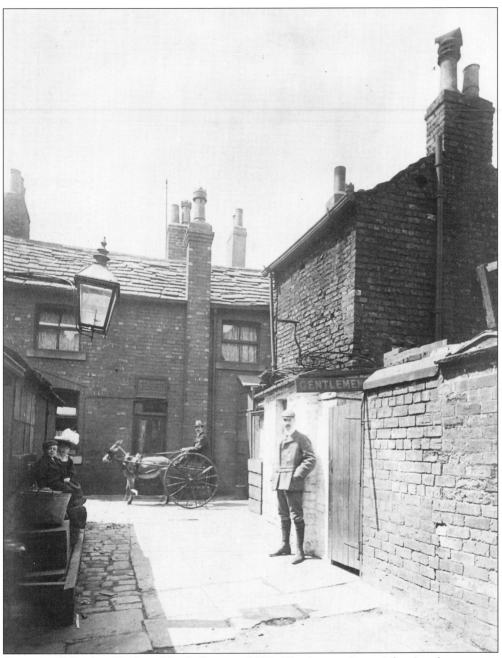

Crown and Anchor Yard on North Street, c.1900. The 'conveniences' for Gentlemen were directly behind the pub.

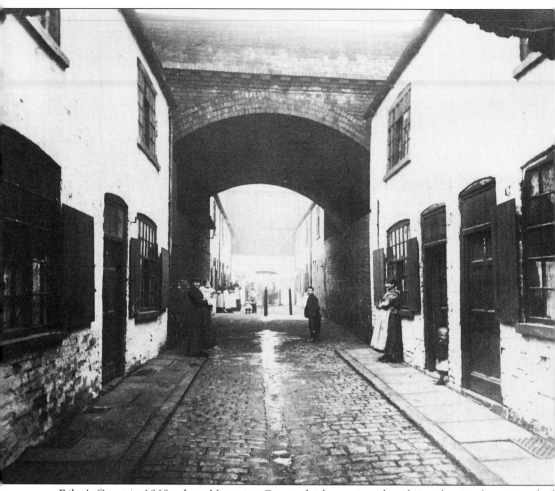

Riley's Court in 1868, a busy Victorian Court which continued to thrive despite the removal of many buildings to make way for a railway viaduct.

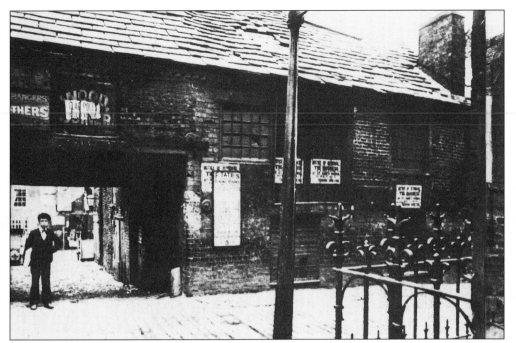

Green Court at the back of Lands Lane c.1890.

The front of the Yorkshire
Hussary Public House c. 1891.

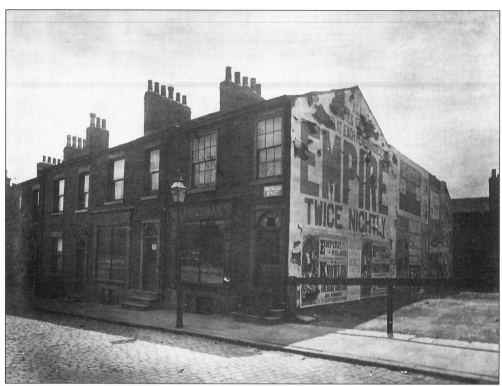

Trafalgar Street in the 1920s.

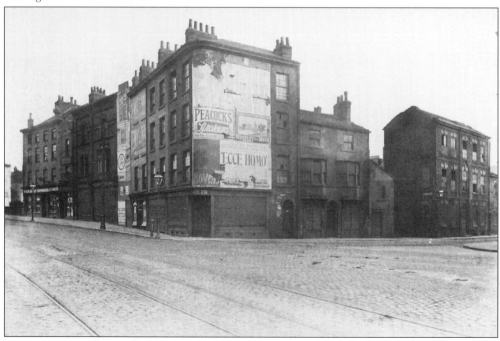

The entrance to Bridge End and Dock Street approaching Leeds bridge c.1900. The building with the bay windows was originally the Seven Stars Inn; just off the picture to the right is the Aldelphi Public House.

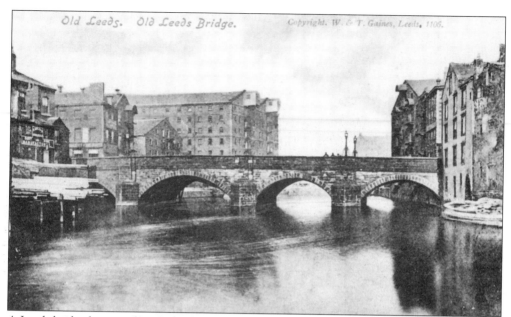

A Leeds bridge has stood at the end of Briggate for nearly 700 years - the original cloth market was held upon it before moving up to Briggate in 1664. The four span arch bridge was built during the reign of James I and was demolished in 1871 to be replaced by a single iron span (102'-6") designed by T.D. Steele of Newport and constructed at a cost of £20,000.

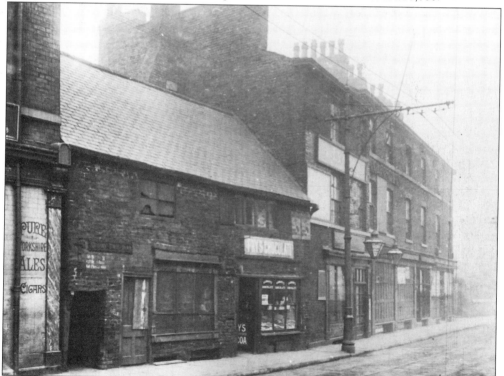

Old buildings opposite the Parish Church c.1910. The entrance to Cherry Tree Yard, a notoriously squalid yard, can be seen on the left.

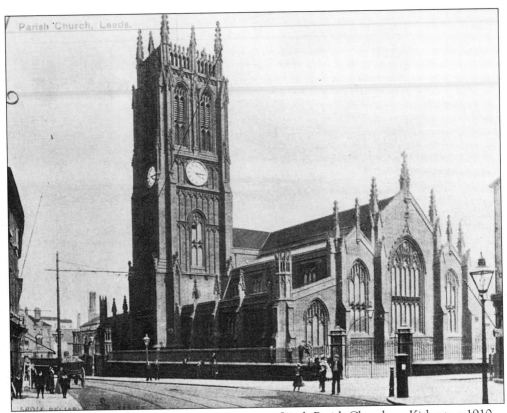

Leeds Parish Church on Kirkgate c.1910.
The architect of the Philosophical Hall
R.F. Chantrell designed the Parish Church
on the site of the old medieval Parish
Church.

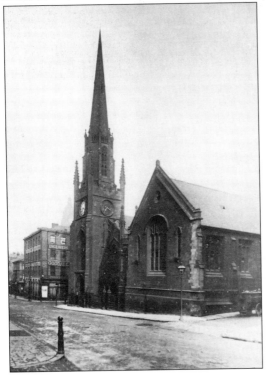

St. Anne's Roman Catholic Church was
on Guildford Street which later became
part of the Headrow. The church was built
in 1838 on a site previously known as Park
Terrace and was constituted a Cathedral
in 1879 as part of a diocese reorganisation.
St. Anne's became something of a traffic
hazard by the turn of the century and was
demolished to be replaced by the present
Cathedral which sits further back on
Cookridge Street.

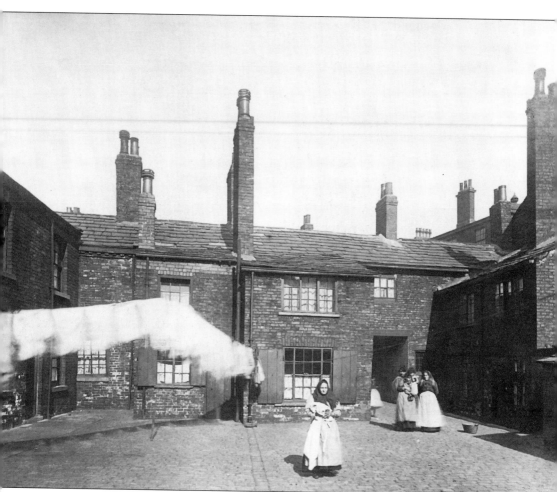

St. Peter's Court on washday c.1880.

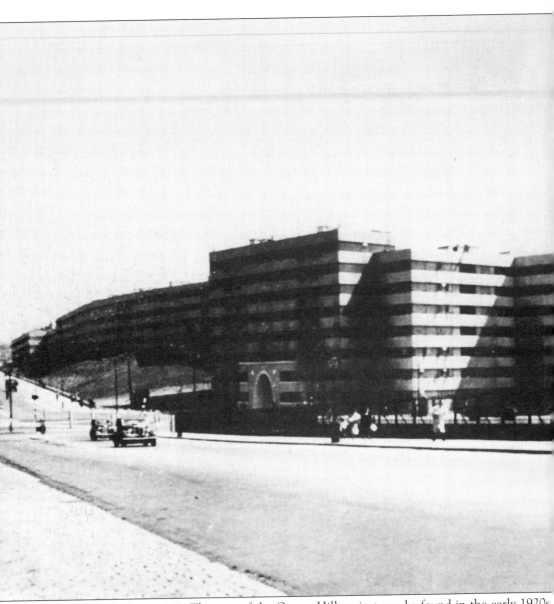

Quarry Hill Flats c.1940. The root of the Quarry Hill project can be found in the early 1920s with various Parliamentary Acts (Addison 1919, Wheatley 1924) and the underlying dictum of Lloyd George that Britain should have 'homes fit for heroes'. Charles Jenkinson, appalled at the conditions he had found in the East End of London, sought to remedy the housing problems of Leeds with a more radical solution and the Quarry Hill Project was born. The flats were to be financed by public funds; projects of the past had been at the mercy of landlords and private developers and any judgement of Quarry Hill must always be undertaken with an understanding of the driving ethos and passion that lay behind the construction: the utilisation of public resources for the benefit of society. The ideas of social justice, positive intervention and Keynesian economics were only beginning to filter through academia to public consciousness and Quarry Hill was a part of that filtration process. Theory, of course, is often found wanting in the face of practical necessities. As Alison Ravetz's wrote in her book 'Model Estate - Planned Housing at Quarry Hill Leeds': 'The significant failure [of Quarry Hill] was one of theory

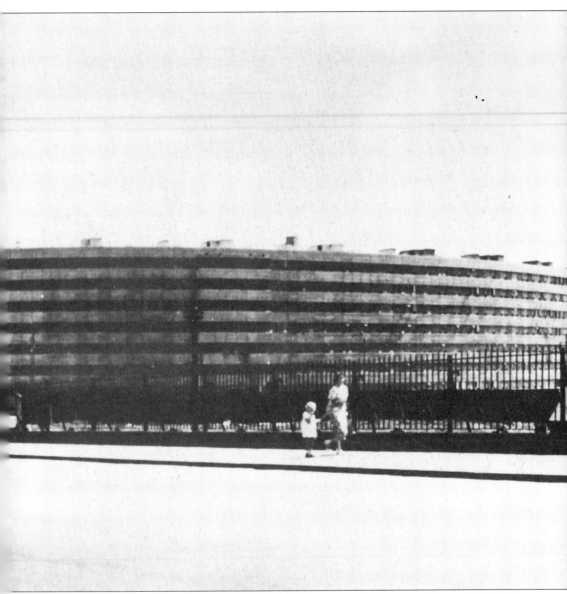

because the model environment, owing to its inherent contradictions, could not fulfil all its intentions . . .'.

The flats, based upon the designs used on the Karl Marx Hof in Vienna, used the Mapin system of stressed steels and concrete. Each 'unit' had an entrance hall, living room facing southwards, a scullery, balcony, bathroom with toilet, five bedrooms with the master bedroom having a built-in wardrobe. Other attractive features were the 'Garchey' system of waste disposal and electric lifts. The flats gained something of 'a reputation' for squalor after the War and were often vilified in the press: 'Quarry Hill Flats ? A slum where the mice bite back' (Yorkshire Evening Post 1953). Many residents however enjoyed living in the flats and A. Bertram wrote in 1938 that Quarry Hill was a 'complete social organism with no gloomy courtyard of stagnant air'. Ultimately the flats were demolished but the memory of the community they created and fostered lingers on.

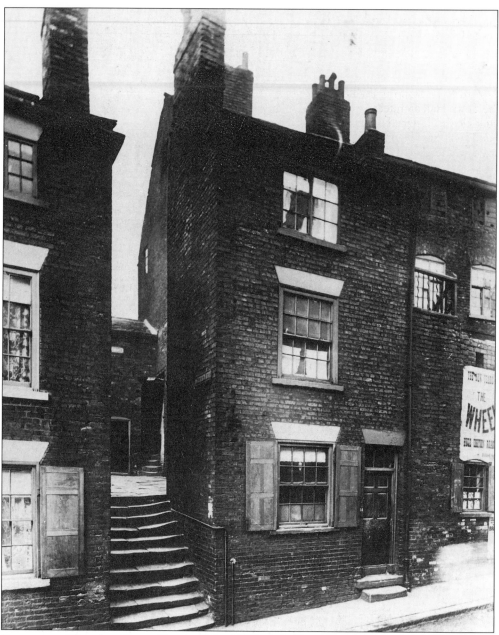

Entrance to Waterloo Court, Quarry Hill c.1890. A 'rabbit warren' of dwellings. In his book 'Leeds Slumdon' (1897) D.B. Foster described the site: 'In this court there are about twenty houses, arranged in an indescribable manner, which must be seen to be believed.'

The interior of Victoria Hall, Town Hall c.1900. The event is possibly a fund-raising effort. The great organ was built by Messrs. Gray and Davison and designed by H. Smart of London. The Town Hall architect Brodrick also designed the glass chandeliers -three of which later furnished the Civic Hall.

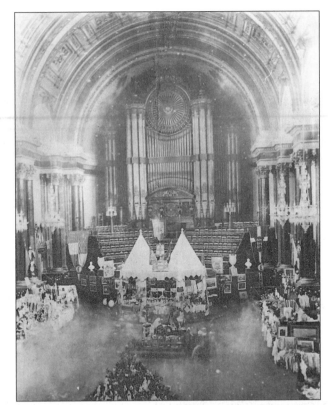

Inside the Assembly Rooms. The Rooms were originally the west wing of the White Cloth Hall and were an extensive tobacconists.

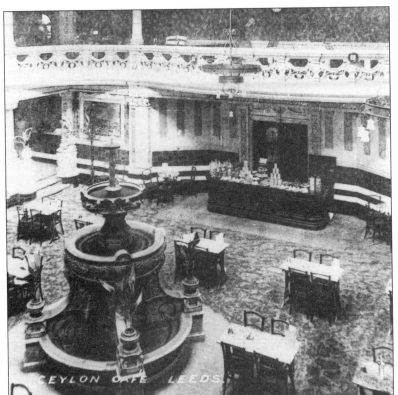

The Ceylon Cafe c.1907. The elegant tea rooms in the County Arcade were purchased by Lyons as part of their national chain. Some years later the cafe became part of the Mecca Ballroom.

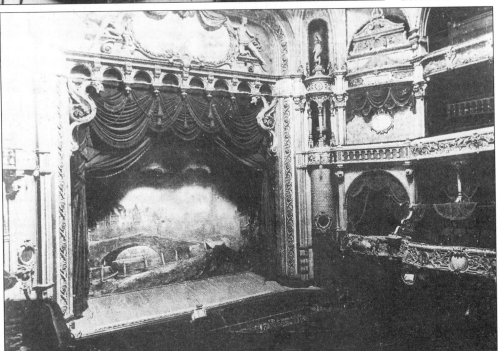

The lavish setting of the Empire Palace. Built during Edwardian times between Briggate and Vicar Lane as part of the County Arcade designed by Frank Matcham.

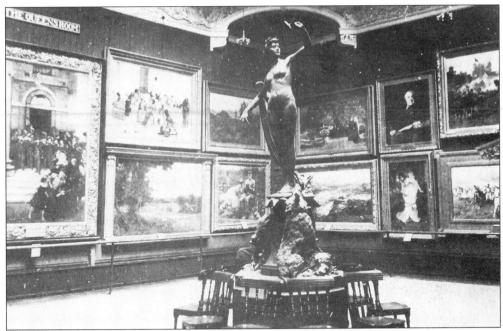

The Queen's Room at Leeds City Art Gallery. The Fine Art Gallery designed by W.H. Thorp was added to the Municipal Building, which contains the Public Library in 1888. This photograph of the sculpture of Circe dates from 1900 and is the work of Alfred Drury. Circe was a particularly nasty witch and enchantress who turned Odysseus' companions into pigs after they drank her potions. Odysseus (Ulysses in Roman Mythology), with admirable foresight and a little help from the Gods, protected himself with a herb called 'moly' and forced Circe to restore his men.

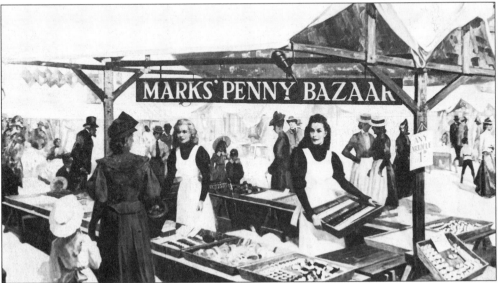

Mark's Penny Bazaar Market Stall opened in 1884 on Tuesdays and Saturdays. The enterprise was started by Michael Marks, a Lithuanian Jew, under the famous dictum 'Don't ask the price - its a penny'. In 1894 he entered a partnership with Tom Spencer and by 1905 there were 70 Penny Bazaars. The Marks and Spencer chain has since become somewhat popular.

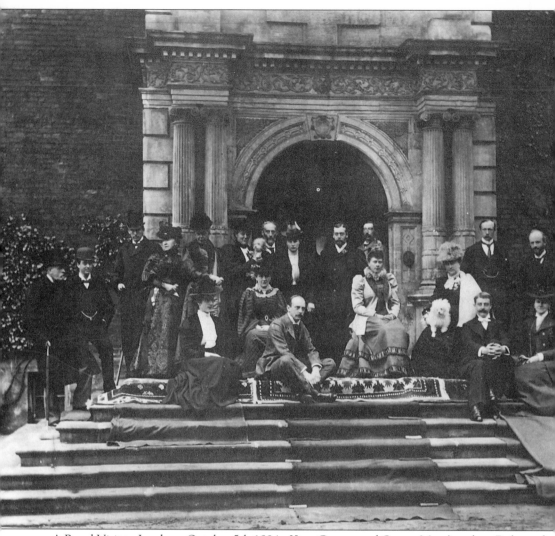

A Royal Visit to Leeds on October 5th 1894 - King George and Queen Mary) as then Duke and Duchess of York) are pictured outside Temple Newsam House. They came to Leeds to open the Yorkshire College Library and Medical School (now part of Leeds University). Those featured are top row, left to right: Sir Francis de Winton, Sir Charles Cust, Viscountess Halifax, Lady Constance Grosvenor, Viscount Halifax, H.R.H. The Duke of York, Sir Stafford Northcote. Middle row: Lieutenant Mark Kerr, Hon. Mrs. Armitage, Countess Grosvenor, Lady Grosvenor, H.R.H. The Duchess of York, Hon. Mrs. Meynell Ingram, Hon, F.L. Wood, earl of Scarborough, Lady Eva Greville. Bottom row: Hon. Mary Wood, Prince Adolphous of Teck, G. Wyndham, Hon. Lady Northcote.

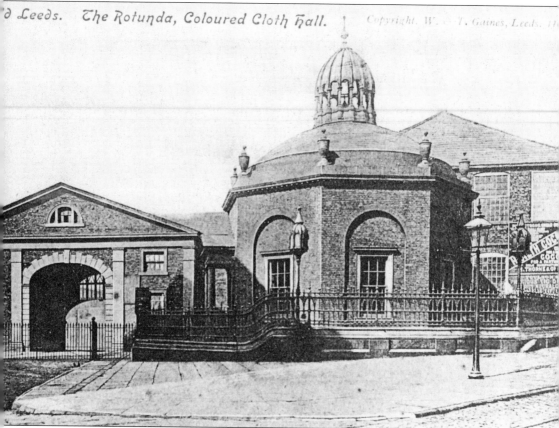

The Rotunda of the Old Coloured Cloth Hall.

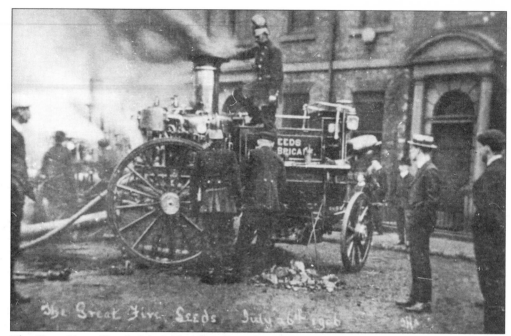

The Great Fire, Leeds, July 26th 1906

The Great Fire of Leeds July 26th 1906 allegedly originated on the evening of July 25th in the upper storeys of the building occupied by Messrs. Hotham and Whiting on Wellington Street. The flames spread across to Thirsk Row and the roof and upper storeys of the Great Northern Hotel which were gutted. Damage was estimated at more than £100,000 and three firemen were injured during the night. In 1879 the Fire Brigade was run in association with the Police. The brigade consisted of a Superintendent, a Sergeant and sixteen Constables; the station house was situated in Fenton Street and contained stables and the steam powered fire engine.

Two
Environs

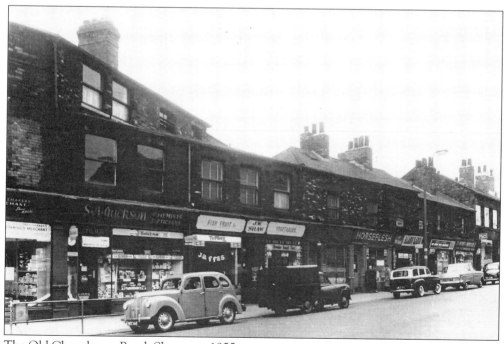

The Old Chapeltown Road, Sheepscar 1955.

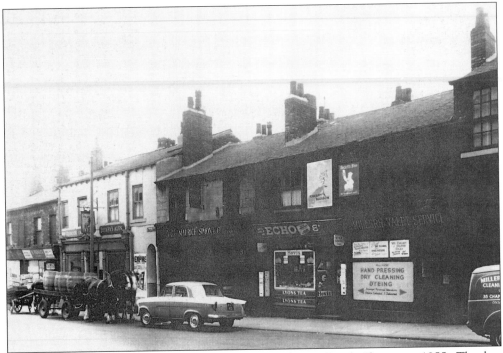

A delivery for The Roscoe Inn on the Old Chapeltown Road, Sheepscar 1955. The last landlord of the Roscoe, Noel Michael Squire, is the present landlord of the New Roscoe which is situated on Sheepscar Street South.

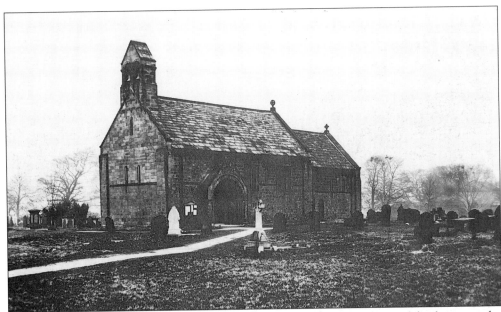

Adel Church c.1900. One of the oldest buildings in the Leeds area and one of the few examples of Norman Architecture dating back to 1150.

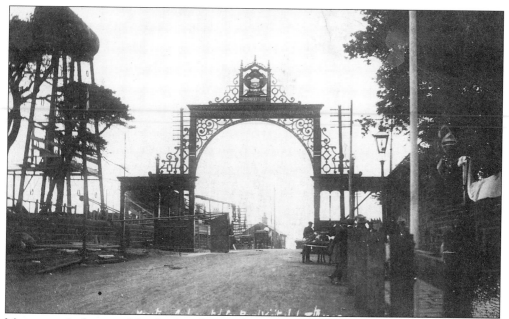

Moortown Arch erected for the Royal Visit of July 7th 1908.

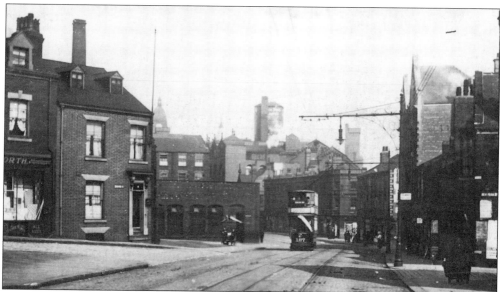

Park Lane leading into the City Centre c.1910.

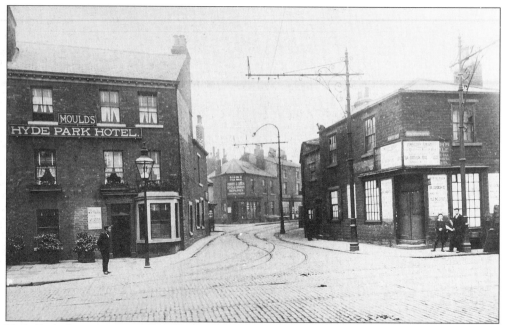

Hyde Park Corner c.1910.

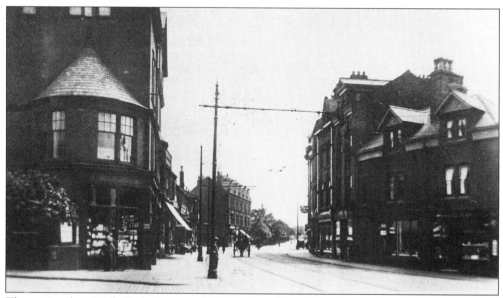

The approach to Hyde Park Corner c.1900, looking down Woodhouse Street, with the original Hyde Park Hotel on the left. The buildings on the right were replaced when the road was widened.

Hyde Park Corner at the junction with Headingly Lane c.1906.

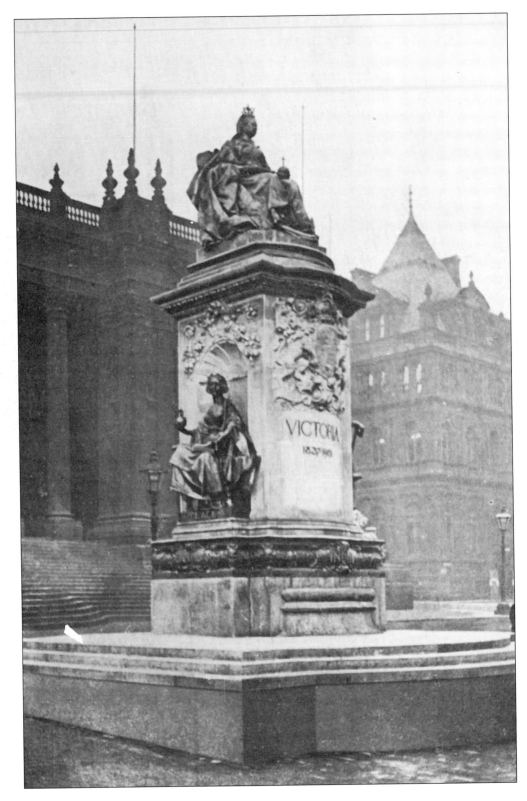

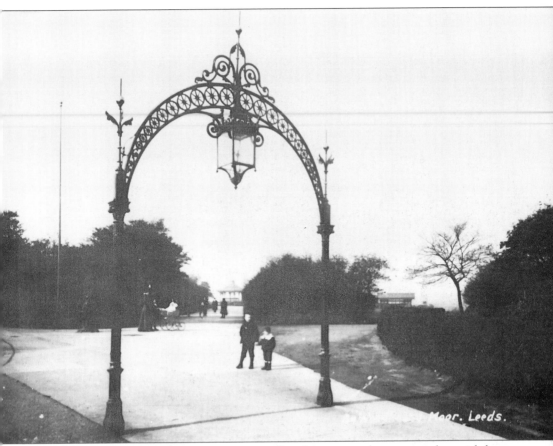

Woodhouse Moor c. 1890. The moor was originally a furze covered moor complete with bogs. During the Napoleonic Wars a crowd had gathered here to form an armed resistance to a possible invasion.

Opposite: Queen Victoria Memorial Statue outside the Town Hall c. 1907. The memorial, cast in bronze from a design by George Frampton, cost £8000 raised by public subscription. She was unveiled by the Lord Mayor on November 27th 1905 and immediately caused problems as the Yorkshire Post described: 'There were critical problems yesterday afternoon when the Lord Mayor was in imminent danger of being deprived of the honour of unveiling the memorial to Queen Victoria. Rude Boreas [wind] was the dreaded usurper. He tugged at the concealing green cover with might and main and curious onlookers were moved by fears perhaps not all together unmingled with hopes that the flapping canvas might be ripped in twain'. The ceremony was completed but the Victoria Memorial proved to be an 'inconvenience' and the onslaught of progress claimed another victim: Victoria was banished to Woodhouse Moor in 1937 along with her fellow exiles Sir Robert Peel and the Duke of Wellington. Sir Robert Peel might well have wished to know why he had annoyed the City of Leeds so much as he was originally moved from Park Row in 1903.

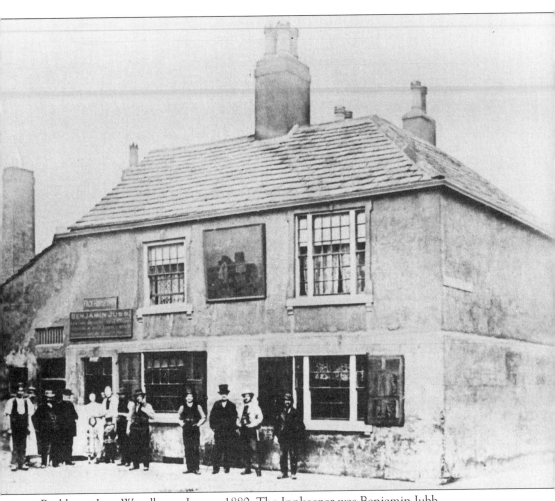

Packhorse Inn, Woodhouse Lane c.1880. The Innkeeper was Benjamin Jubb.

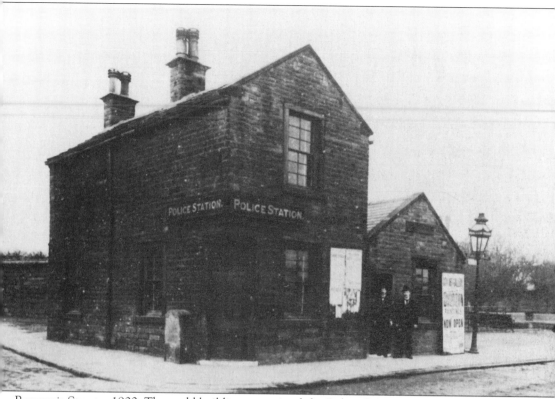

Reservoir Street c.1900. These old buildings contained the Police Station: a new station and a Library (a usual mixture at this time to save public funds) were later built on this site and today forms part of the 'Feast and Firkin Pub' opposite the Engineering Department of Leeds University. The underground reservoir and surrounding wall are still standing but the street name was removed and became part of an extended Clarendon Road.

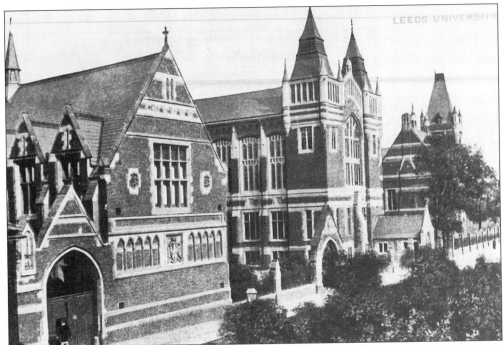

Leeds University was originally titled Yorkshire College of Science and was based at Cookridge Street. It became the Victoria University in 1887 and after receiving the University Charter on April 25th 1904 became Leeds University. The original curriculum was predominantly scientific but this was widened after 1878 to include English, French, Classics and History.

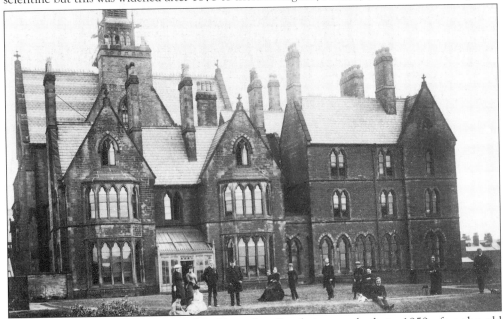

Leeds Grammar School c. 1893. The Clarendon Road site was built in 1859 after the old premises in the city centre came into disrepair. This photograph was taken shortly before extensions were made in 1894. Rumours persist that the University wishes to purchase the Grammar School and its grounds.

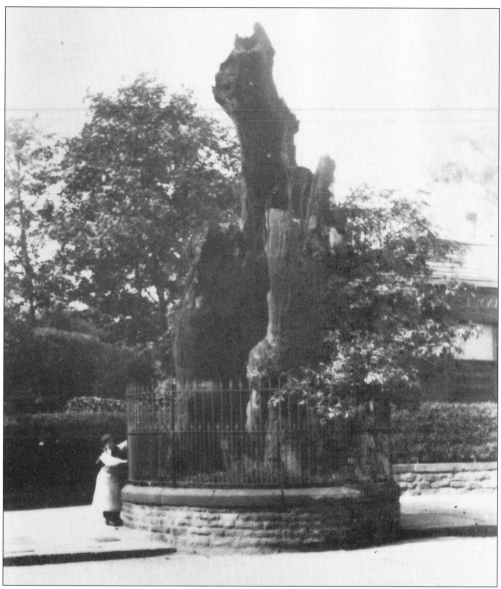

The Shire Oak at Headingley c.1910. The Oak was viewed with much affection by locals in Headingley and after its collapse on May 16th 1941 the Yorkshire Post wrote a sad lament: 'Headingley is accustomed to collapses. Has not even England collapsed there before now, when the Australians have proved too deadly? But a collapse took place yesterday which the most hardened Headingleyite could not see without a pang. The Shire Oak, which has braved the breeze in those parts probably since the days of the Saxons, suddenly fell forward on the rails that protected it'. For many years the Oak had been a shell but a month before the collapse the Leeds Corporation Improvements Committee had decided to place a steel support within the shell. As metal was scarce and the military priority took precedent no steel could be found: it is possible that the old Oak, sensing the nation's need to be greater, took the decision out of the Committee's hands. Tradition had stated that the Oak had been the meeting place for Saxon Chieftains, the headmen of the old 'hundreds' and was also used in Roman times as a signal station.

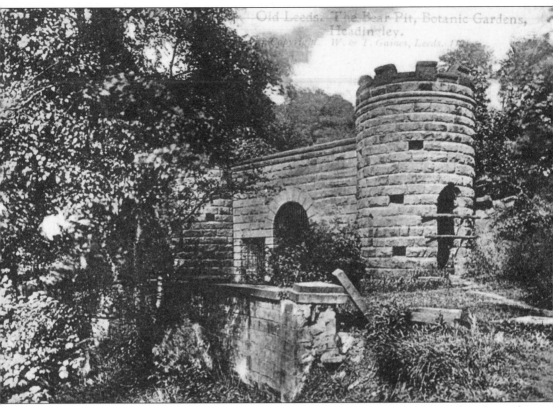

Old Leeds. The Bear Pit, Botanic Gardens, Headingley.
W. & T. Gaines, Leeds.

The Botanical and Zoological Gardens were situated between Headingley and Burley and were opened in 1840. The original cost of the land, buildings and landscaping was £11,000. There was a small collection of animals, two fish ponds and some ornate bridges. The cost of entry in the first year of opening was 6d; for children under thirteen years of age and servants having charge of such children the cost was 3d. The bears lived in a circular pit behind a portcullis from which the poor creatures could be leered at by the paying public.

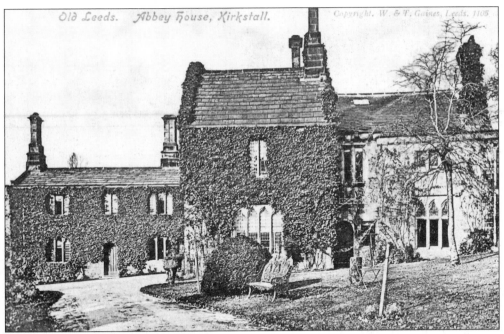

Abbey House, Kirstall. The old gatehouse for the Abbey had been inhabited as a dwelling since 1539 but eventually passed into the ownership of the Leeds Corporation.

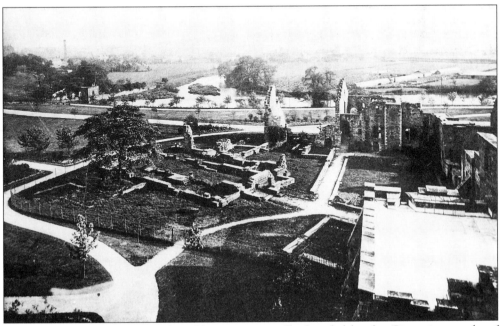

The Abbey grounds c.1900. The Abbey was originally founded by the Cistercian monks of Barnoldswick in 1132.

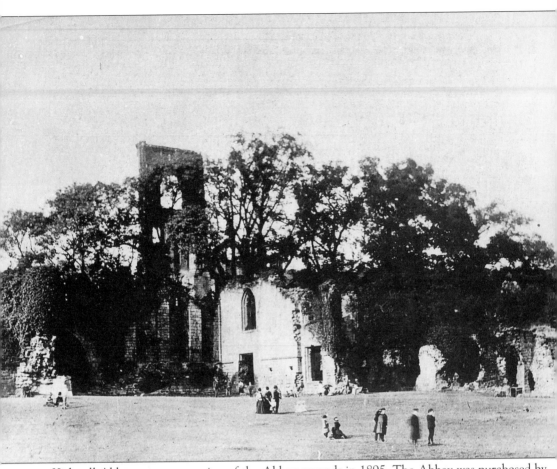

Kirkstall Abbey upon re-opening of the Abbey grounds in 1895. The Abbey was purchased by the philanthropic Colonel North from the Cardigan Family after the death of the Earl in 1888, who afterwards presented it to the City of Leeds. In 1890 the Council, acting upon a report produced by W.H. St. John Hope, set upon a 'five year plan' to restore the Abbey and make the grounds into a public park. Colonel North made his fortune, quite literally, from 'dung'. Droppings from tropical birds contained nitrates which were shipped to Europe for use as fertilizers.

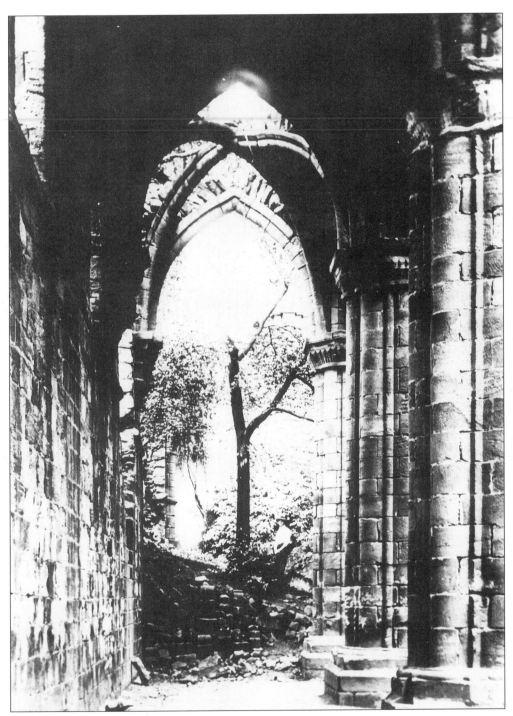

Kirkstall Abbey in Edwardian times.

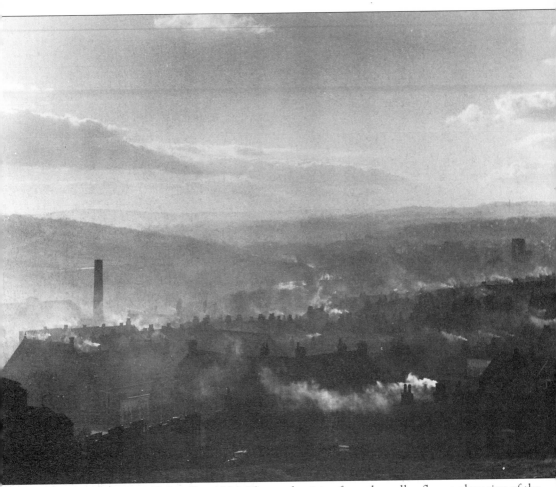

A view overlooking Kirkstall in 1956. The smoke rising from the valley floor a clear sign of the economic prosperity of that decade - although something of a health hazard.

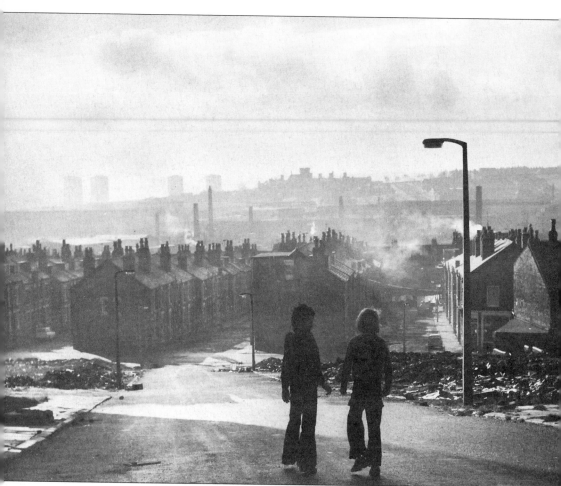

A view down Cardigan Lane, Burley 1976. In the distance is the square turret of Armley Gaol: the photograph was probably taken on the corner of Burley Road near to Burley House and St. Mattias Primary School.

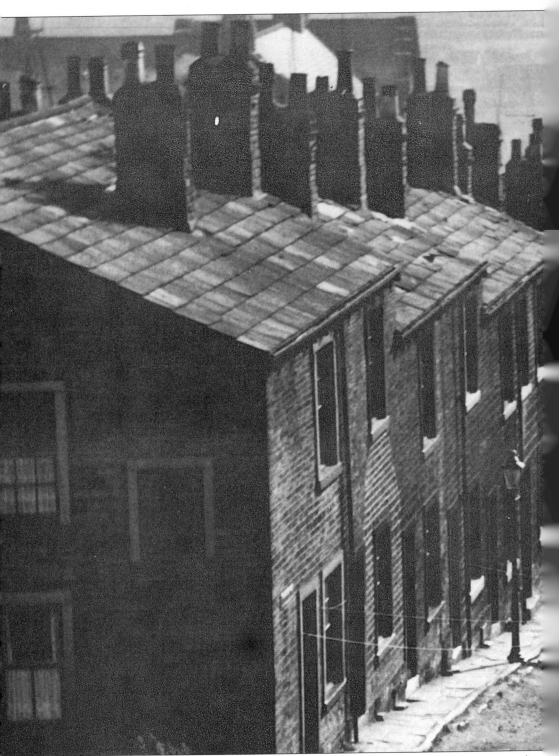

Aaron's Row at the back of Beecroft Street, Kirkstall 1970. The Old School house can just be seen on the top left.

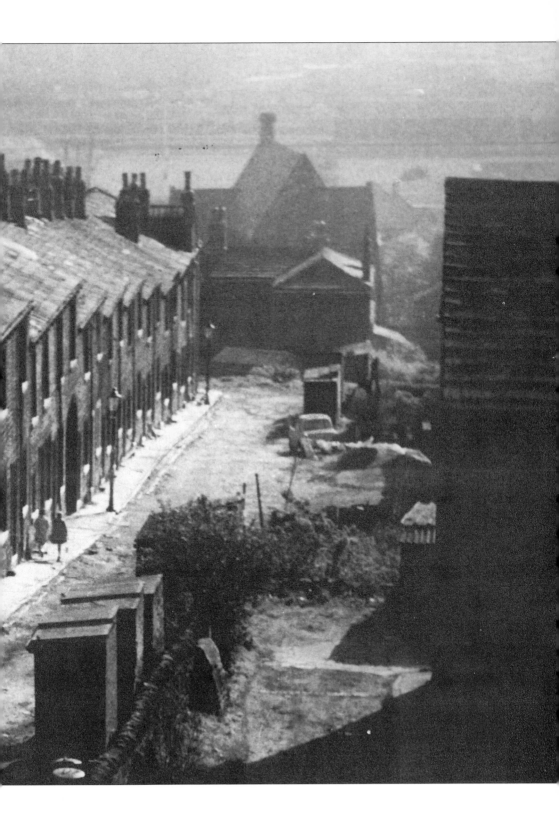

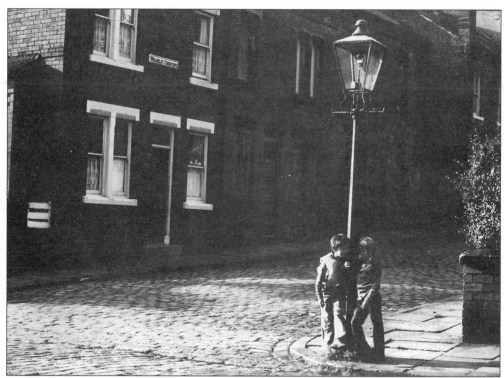

Wolseley Crescent, Burley 1976. The Crescent stood on the site of Wolseley Road and St. Mattias estate.

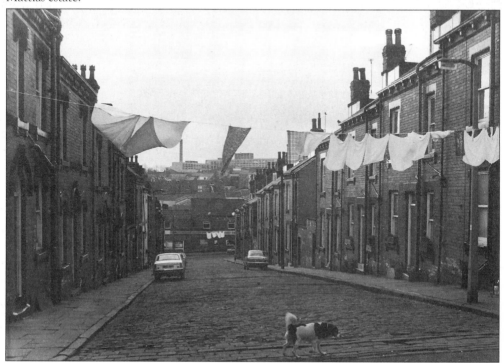

A view down a Kirkstall Terrace c.1976.

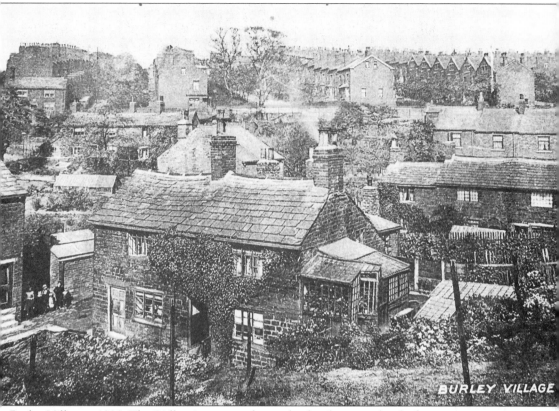

Burley Village c.1900. The 'Village' was ripped apart by developers and only the name remains today.

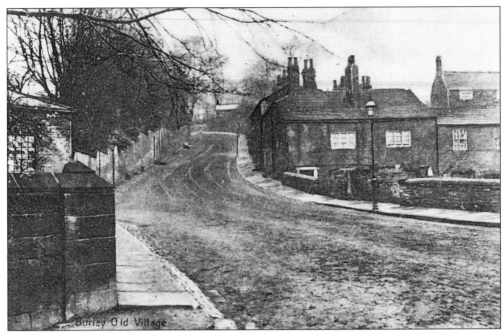

A view up the Burley Road c.1900. Today terraces and shops dominate the left side of the road.

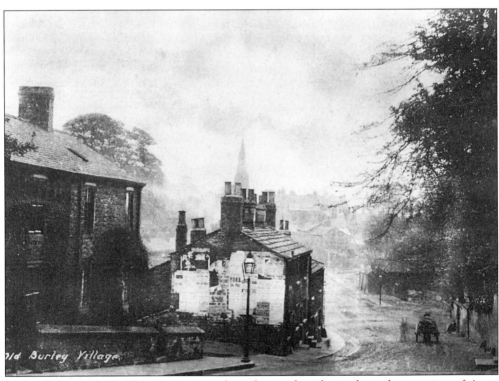

Burley Village c.1900. This picture must have been taken from where the junction of Argie Terrace and St. Michaels Lane meet.

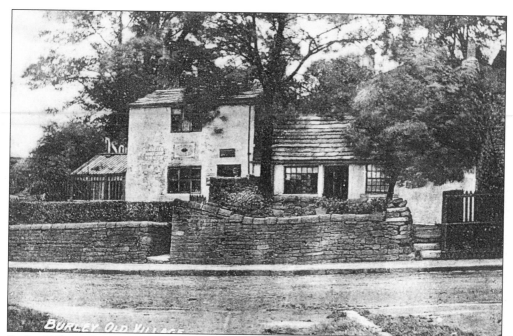

Burley Village Shop c.1900.

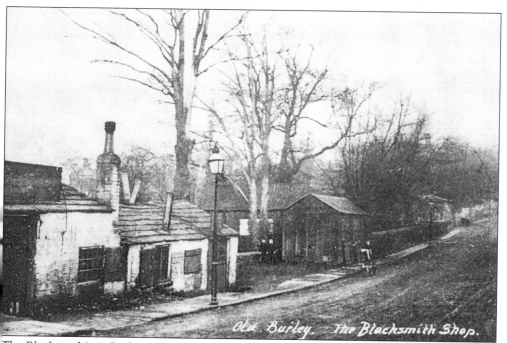

The Blacksmith's in Burley 1900.

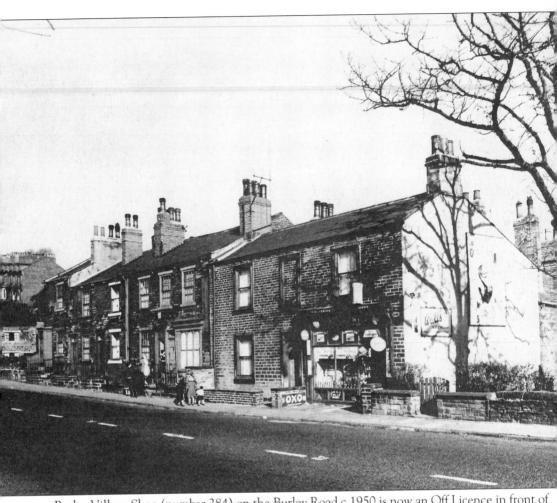

Burley Village Shop (number 284) on the Burley Road c.1950 is now an Off Licence in front of the park and is the only part of this terrace left standing.

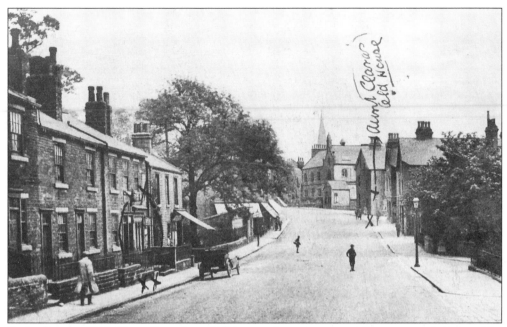

Burley Road c.1912. The village shop (Off Licence) can be seen with a canopy; the spire of St. Mattias Church is in the distance. The notation on this photograph read 'Aunt Clara's House' - a building which was demolished to make way for the entrance to Greenhow Gardens.

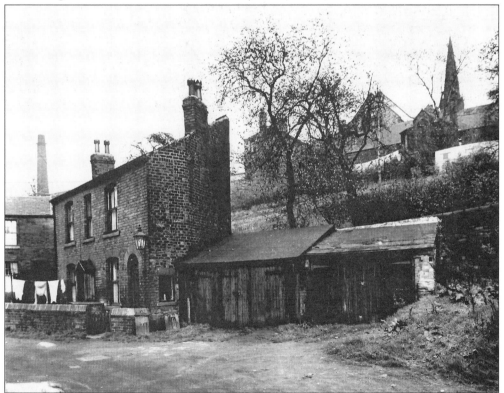

Burley Village c.1950. The spire in the background belongs to Burley Methodist Church.

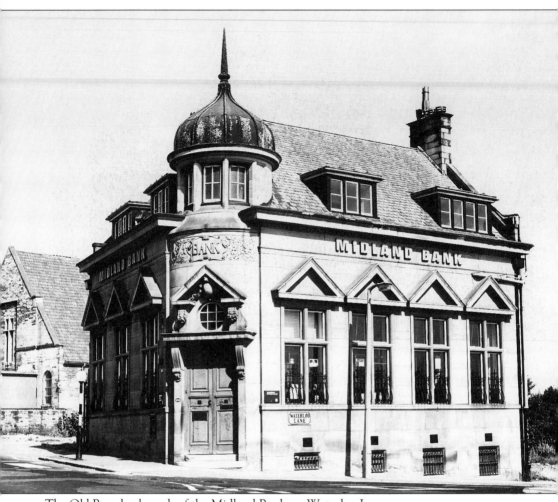

The Old Bramley branch of the Midland Bank on Waterloo Lane.

Opposite: The Acorn Inn, Bramley Whitecotes c.1970. Hammonds Ales were purchased by Bass soon after this date and the pub was one of the few buildings to survive after the demolition of much of Whitecotes.

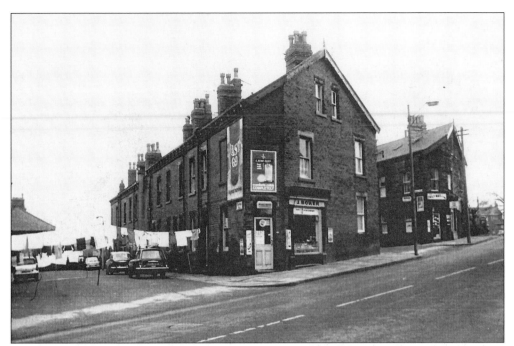

Bramley Town Street and Highfield Place with J. Bower's on the corner c.1970. Town Street, the heart of Bramley, was essentially ripped apart by developers in the 1960s and 70s. These great housing projects began in 1959 and were completed in 1978 - the old 'Yards' having been swept away in the process. A Yard was an enclosed piece of land containing workshops, homes and a larger house owned by the person with enough money to maintain all the properties: the Yards would usually be named after these prominent individuals and hence Farrer's Yard, Turner's Yard and Ebenezer Place.

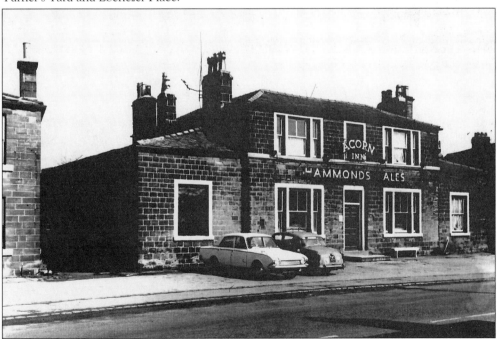

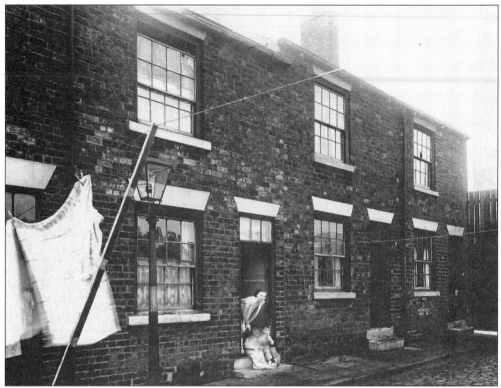

An open doorway in an Armley Terrace c.1959.

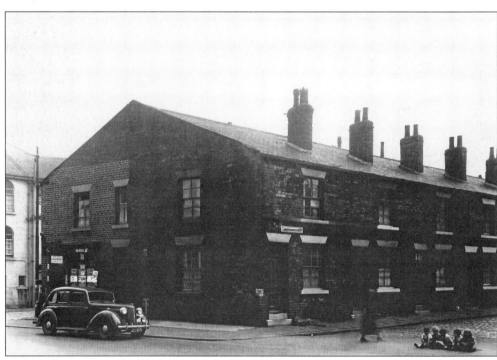

Londesborough Terrace, Armley c.1959.

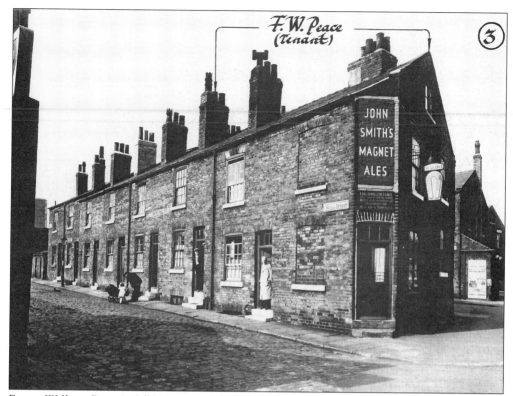

Fergus William Peace's Off Licence on Neill Street, Armley c.1960.

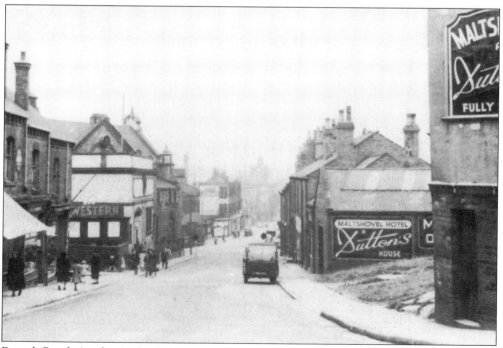

Branch Road, Armley in the 1940s.

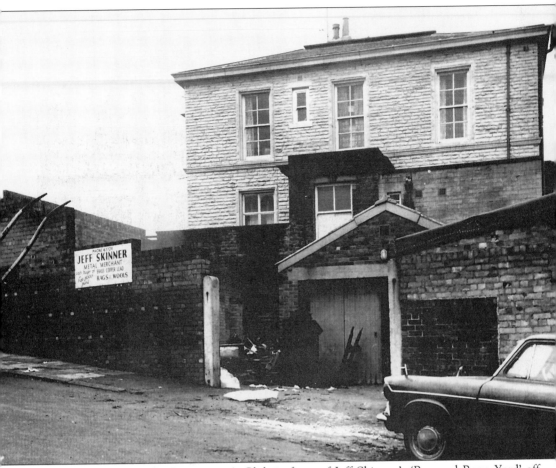

The Victory House Ex-Servicemen's Club in front of Jeff Skinner's 'Rag and Bone Yard' off
Parliament Road c.1960. Today the Club is in a state of disrepair; Jeff Skinner's yard is a parking
place on the entrance to the new houses of Parliament Place. The site is opposite the Armley
Gaol and the Holy Family Roman Catholic Primary and Nursery School.

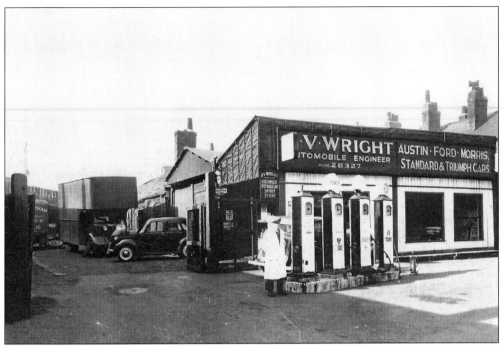

A.V. Wright's, Armley, which once advertised the 'amazing five minute car wash'.

Abbott Terrace on the corner of Parliament Road c.1960.

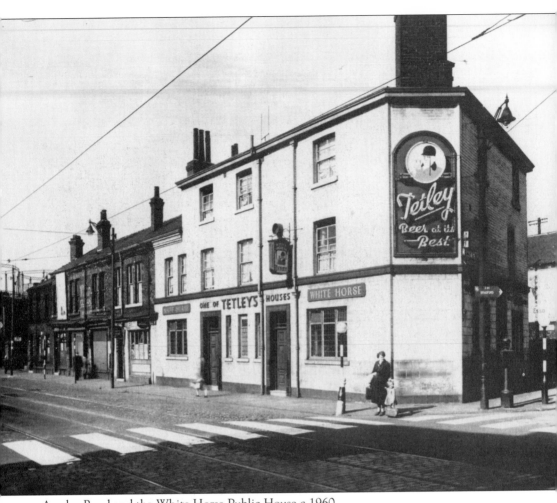

Armley Road and the White Horse Public House c.1960.

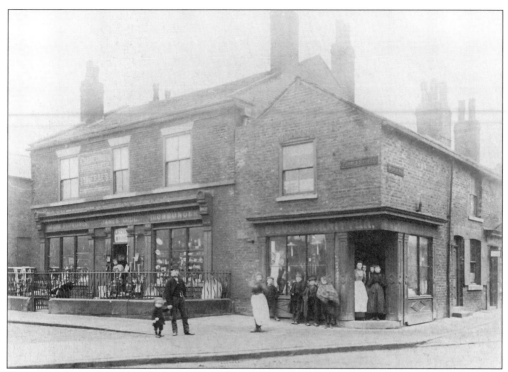

Houses at the end of Church Street, Hunslet c.1890.

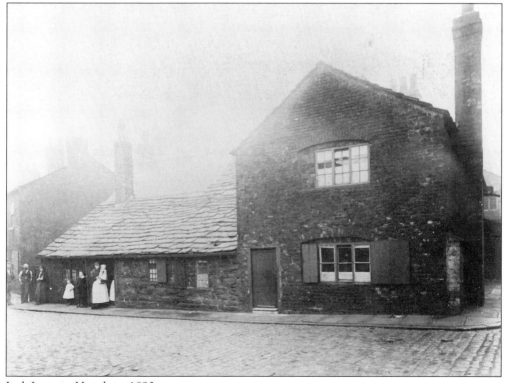

Jack Lane in Hunslet c.1890.

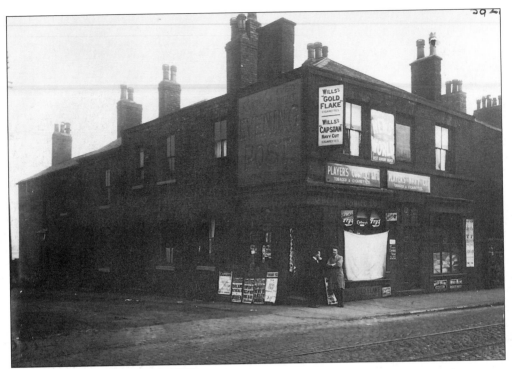

Highgate Street in Hunslet in 1920.

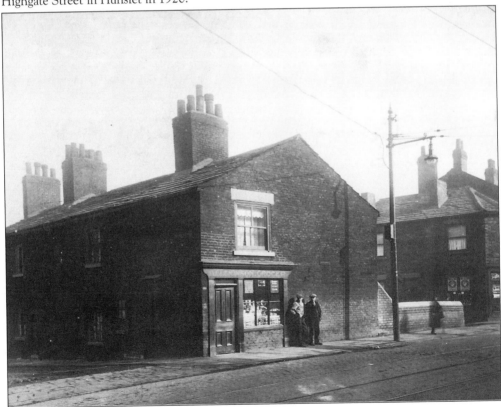

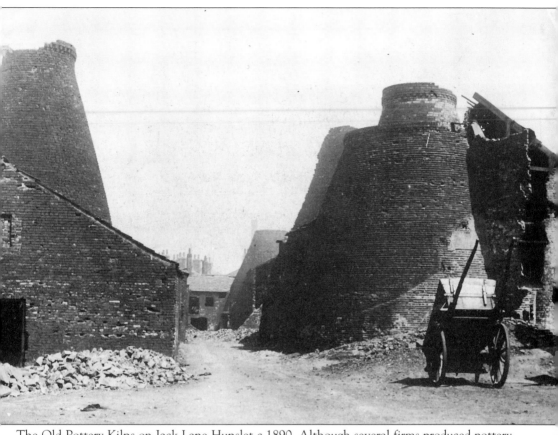

The Old Pottery Kilns on Jack Lane Hunslet c.1890. Although several firms produced pottery in Leeds during the Eighteenth and Nineteenth Centuries the most famous were the Green Brothers established in 1760. These kilns closed in 1878.

Opposite: Brown's Place, Hunslet 1925. Annie Cleminson owned the Grocer's pictured here while the next shop belonged to 'Wild Willie Hairdressers'.

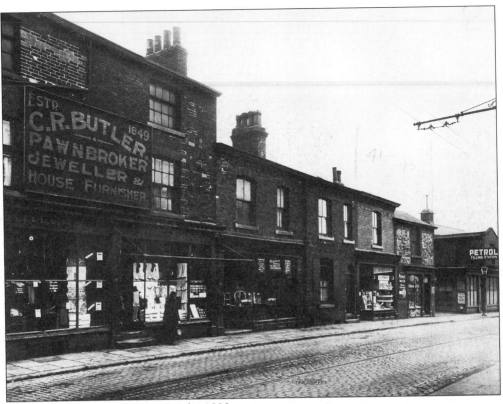

C.R. Butler's Pawnbrokers in Hunslet 1930.

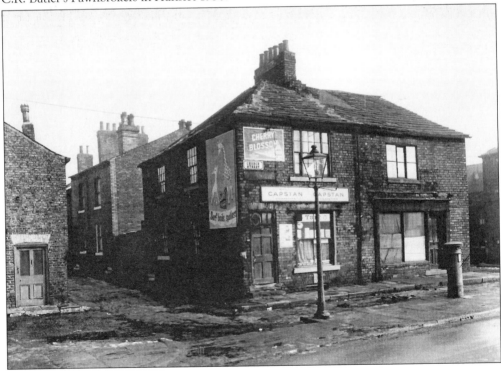

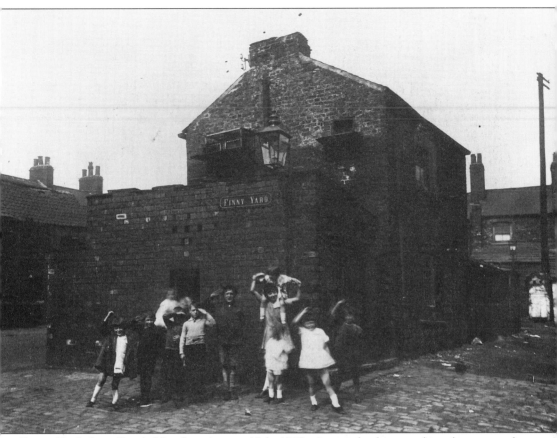

Finny Yard, Low Road, Hunslet, August 13th 1929. A superb photograph and a personal favourite.

Opposite: Church Street, Hunslet c.1955. Much of Church Street was swept away in a frenzy of re-development. Only a few remnants remain: the Sun Hotel which sits eerily alone around a sea of red bricks and the Church Spire with its newly acquired nave. Number 61 pictured here stood on the site of the present Hemmingway Close.

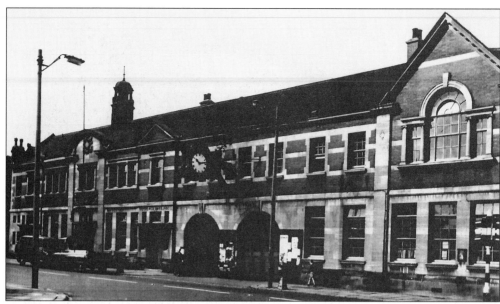

Hunslet Library, Police Station and Juvenile Court in 1964, on the corner of Dewsbury Road and Hunslet Hall Road. Tradition and financial necessity in Leeds has often placed the Police and the Library Service in the same building; the Police have since moved premises and the Library has now been joined by the Juvenile Probation Service.

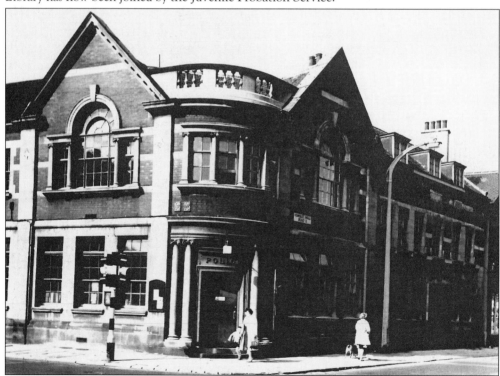

The Old Police Station, Hunslet Hall Road 1964. Part of this building (from the lamppost onward) has since been removed to accommodate the building of the Evangelical Church of the Nazarene.

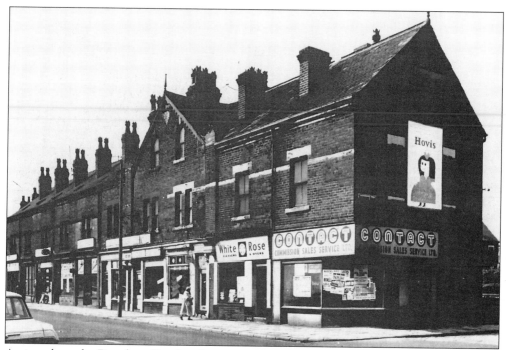

A view along the Dewsbury Road at the corner of Roxburgh Road, Hunslet in 1964.

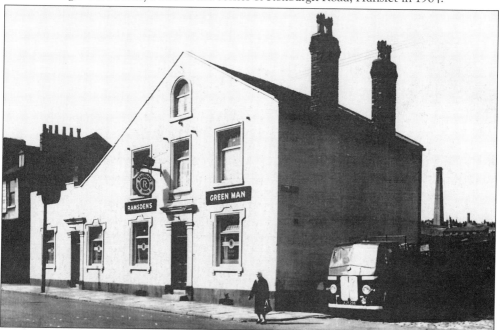

The Green Man Pub on Dewsbury Road and the corner of Vicar Street c. 1964. The area behind the pub is now vacant apart from Dewsbury Road Tyres and Lewis Johnson builders. The pub was a hundred yards from the Library and Juvenile Court and some locals remember that it was possible to make an 'appearance before m'lord in the morning and before the landlord by lunchtime'. At one time there were more than twenty pubs just along the Dewsbury Road.

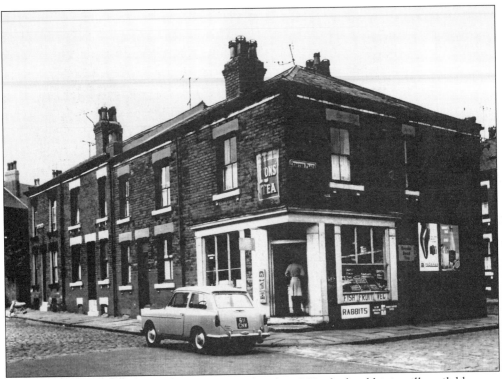

A shop on the corner of Chester Place, Hunslet in the 1960s; fresh rabbit is still available.

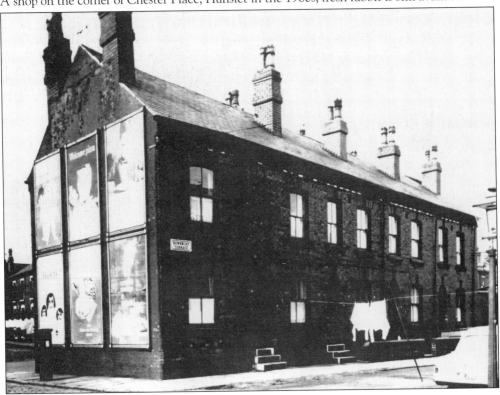

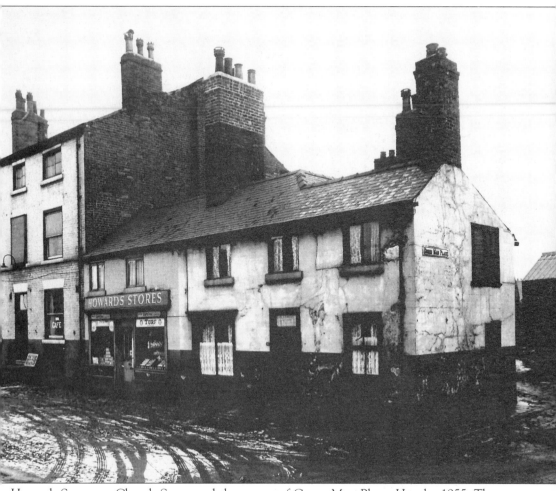

Howards Stores on Church Street and the corner of Green Man Place, Hunslet 1955. These buildings stood on the site of the bus stop directly opposite what is today the Penny Hill Shopping Centre. It is extremely difficult to visualise where these buildings stood such has been the extensive development in Church Street.

Opposite: A washing line across Dewsbury Terrace - just off the Hunslet Hall Road.

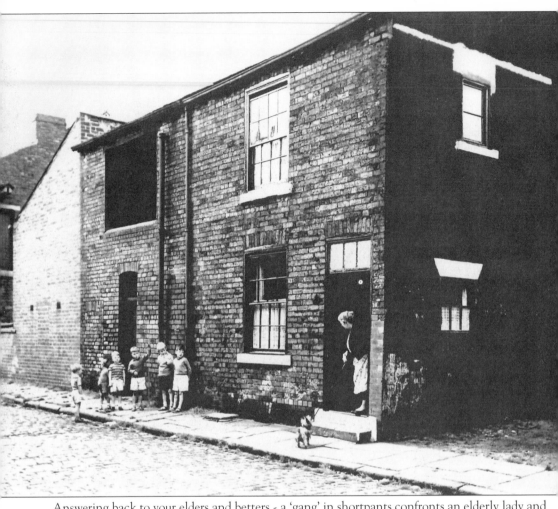

Answering back to your elders and betters - a 'gang' in shortpants confronts an elderly lady and guard dog on the corner of Mount Place and Selbourne Street, Hunslet c.1960.

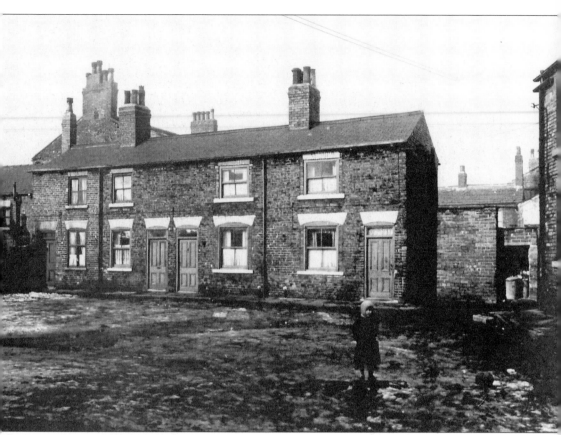

An old Yard just off Church Street near Moor End 1955.

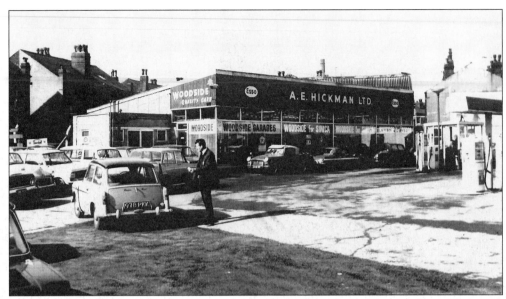

A.E. Hickman Ltd were on Pepper Lane and Rocheford Place near Thwaite Gate. The site is now part of a housing estate.

Workers on a 'tea and smoke' break outside M. Sanderson (Metal Finishers) which were located on Alpha Street just off the Dewsbury Road c.1964.

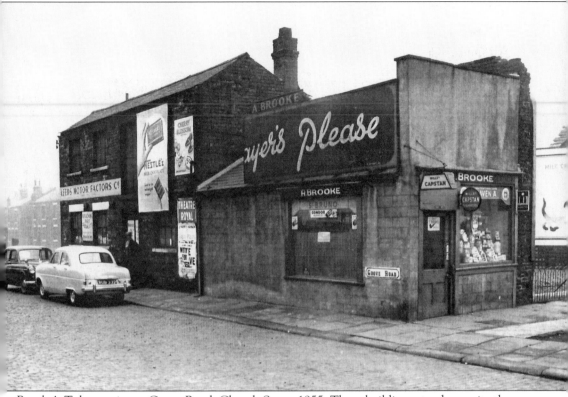

Brooke's Tobacconist on Grove Road, Church Street 1955. These buildings stood opposite the contemporary Church Street Surgery and George IV public house. The land behind is now a small childrens park but this is to be replaced under the auspices of the Leeds Development Corporation.

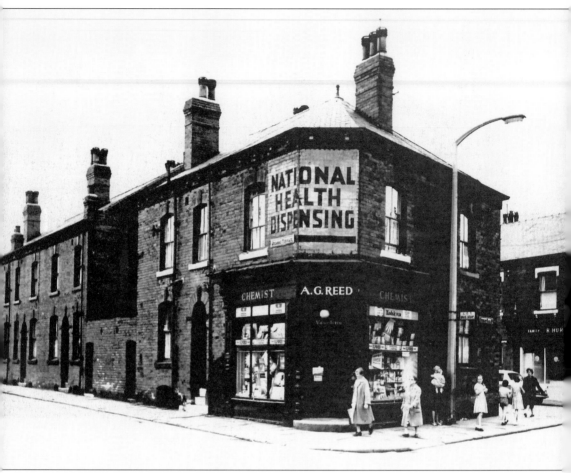

A.G. Reed's Chemist on the corner of Jesmond Terrace and Hunslet Hall Road c.1960. The construction of the M621 transformed Hunslet Hall Road from a busy main road to a quiet backstreet.

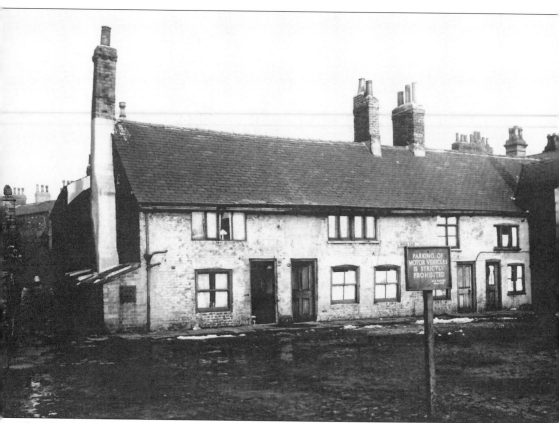

Church Street, Hunslet c.1950. On this site today is The Vale Day Centre and the Copper Hill Nursing Home.

Old shops on the Dewsbury Road c.1960.

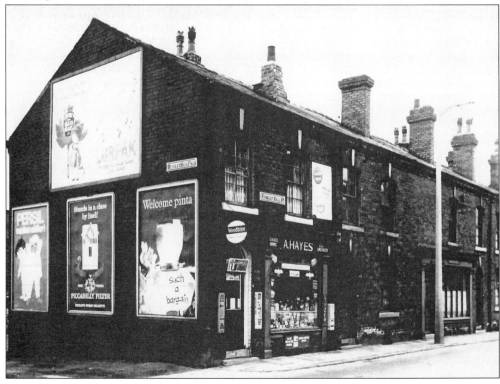

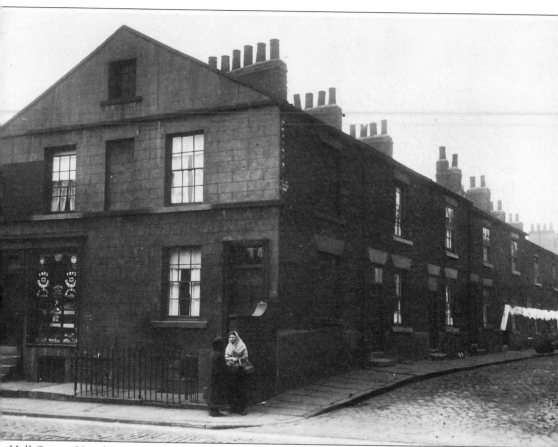

Hall Street, Hunslet, on the corner of Low Road c.1912. The confectioners shop belonged to Thomas Cooper (who owned three such businesses in the Hunslet area). According to Kelly's Street Directory the vast majority of those living in Hall Street were labourers but there were also two boiler makers and a miner.

Opposite: A. Hayes Newsagents on the corner of Hunslet Hall Fold and Hunslet Hall Road c.1960.

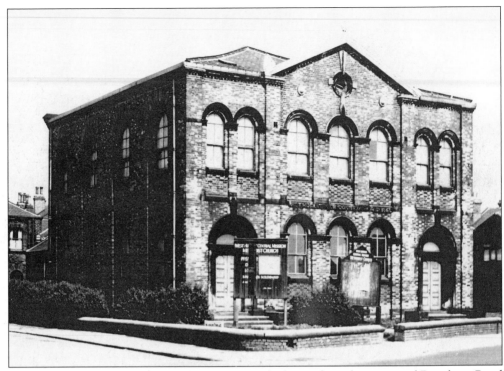

The West Hunslet Central Methodist Mission which stood on the corner of Dewsbury Road and Ladbroke Place.

Beeston Hill c.1910.

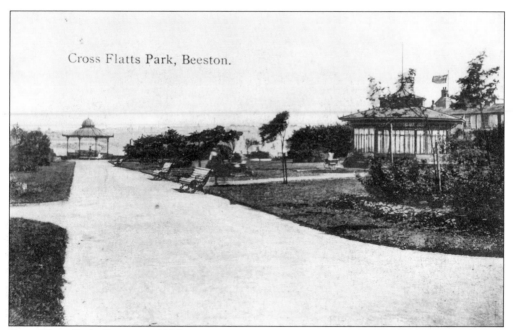

Cross Flatts Park, Beeston c.1900.

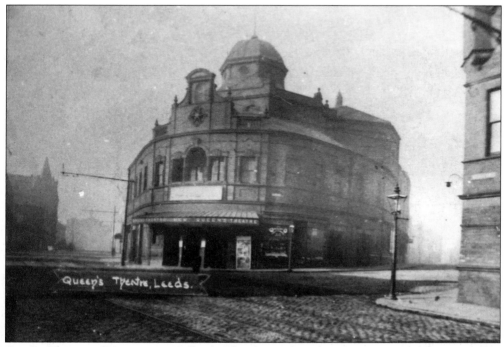

Queens Theatre of Varieties in Holbeck. The theatre later became a cinema and one member of the Yorkshire Archaeological Society remembers being asked to leave for 'laughing during the premiere of a Dracula film'.

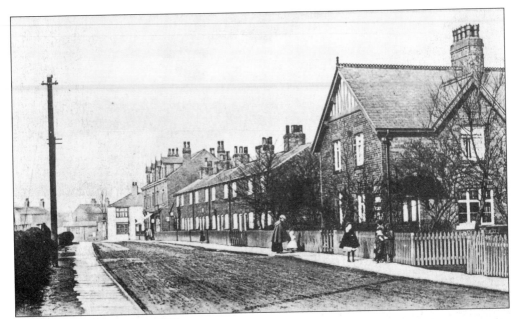

Station Road, Crossgates c.1901.

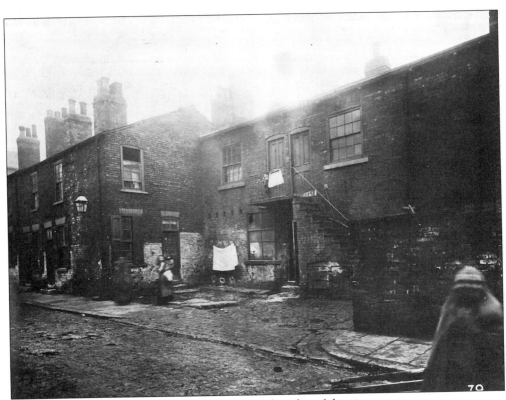

An unknown court scene from 1890 probably on the edge of the city centre.

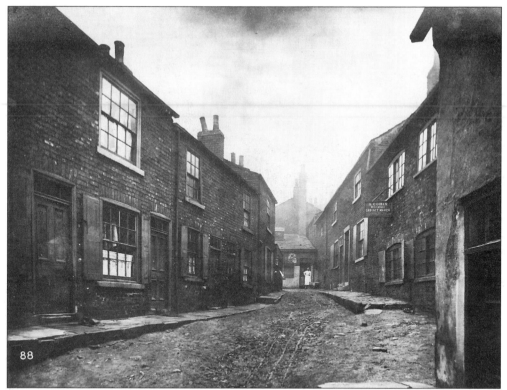

S. Cohen Cabinet Maker was a shop situated at Tunstall's Fold just north of Mabgate.

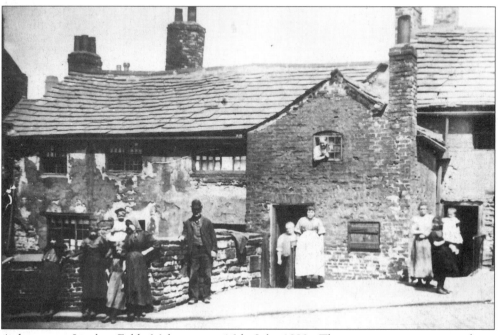

A house at Linsley Fold, Mabgate on 16th July 1899. This area was soon to undergo development.

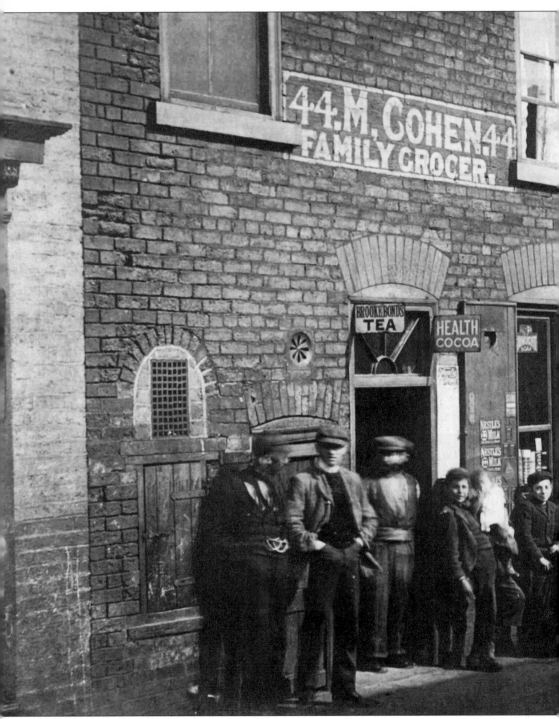

Locals pose outside Cohen's Family Grocer at the turn of the century. The shop was located on Bridge Street, Leylands near North Street.

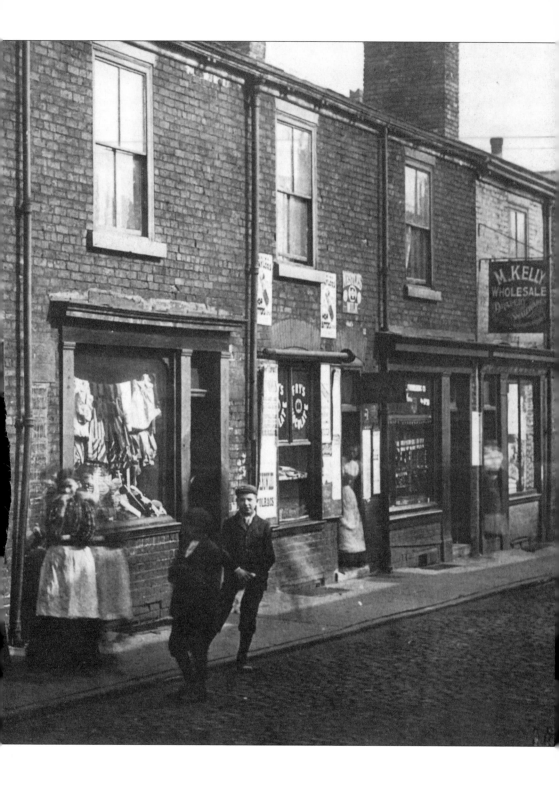

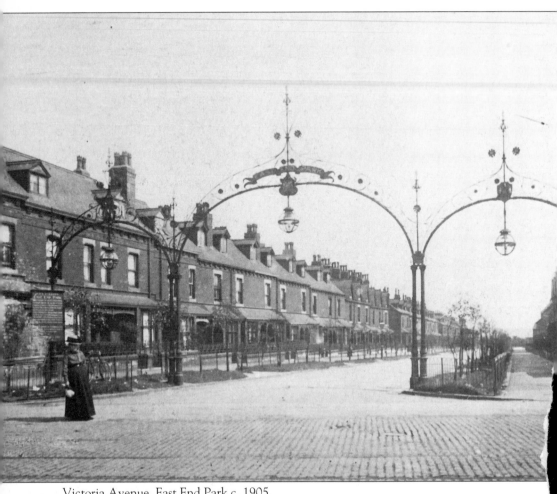

Victoria Avenue, East End Park c. 1905.